Andy with
George Klauber
21st. ST. N.Y.

Photo P. Pearlstein

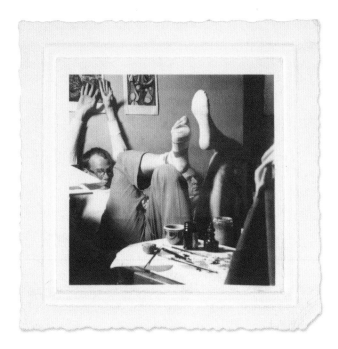

ARTISTS
UNFRAMED

Snapshots from the Smithsonian's
Archives of American Art

MERRY A. FORESTA

ARCHIVES OF AMERICAN ART
SMITHSONIAN INSTITUTION, WASHINGTON, D.C.

in association with

PRINCETON ARCHITECTURAL PRESS, NEW YORK

PUBLISHED BY

Princeton Architectural Press
37 East 7th Street
New York, New York 10003
www.papress.com

Printed and bound in China by C&C Offset Printing Co.
18 17 16 15 4 3 2 1 First edition

EDITOR: Sara Stemen DESIGNER: Benjamin English

SPECIAL THANKS TO: Meredith Baber, Sara Bader, Nicola Bednarek Brower,
Janet Behning, Erin Cain, Megan Carey, Carina Cha, Andrea Chlad,
Tom Cho, Barbara Darko, Russell Fernandez, Jan Cigliano Hartman,
Jan Haux, Diane Levinson, Jennifer Lippert, Katharine Myers, Jaime Nelson,
Rob Shaeffer, Marielle Suba, Kaymar Thomas, Paul Wagner, Joseph Weston,
and Janet Wong of Princeton Architectural Press — *Kevin C. Lippert, publisher*

Library of Congress Cataloging-in-Publication Data:
Archives of American Art.
Artists unframed : snapshots from the Smithsonian's Archives
of American Art / Merry Foresta. — First edition.
pages cm
Includes bibliographical references.
ISBN 978-1-61689-295-1 (hardback)
1. Artists—United States—Pictorial works—Exhibitions.
2. Photography—United States—Exhibitions.
3. United States—Biography—Portraits—Exhibitions.
4. Archives of American Art—Exhibitions.
I. Foresta, Merry A., author. II. Title.
N6536.A72 2015
709.2'2—dc23 2014027487

FRONTISPIECE:
Andy Warhol with George Klauber, Studio on Twenty-First Street, New York City, ca. 1949
Photograph by Philip Pearlstein, Philip Pearlstein Papers, 1949 – 2009

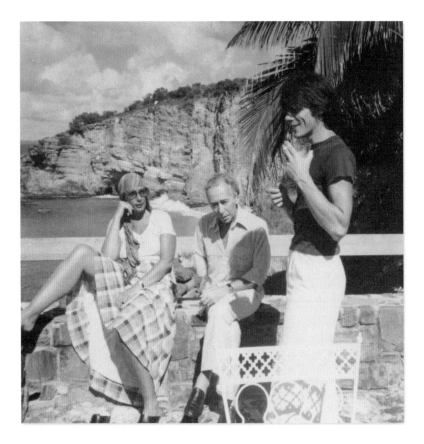

FOREWORD

Snapshots are everywhere. Some are meticulously labeled and organized in photograph albums, while others are haphazardly thrown into shoe boxes and stashed in closets. In the digital era, snapshots are stored on our smartphones and shared widely on social-media sites. Snapshots are fertile ground for moments of rediscovery, when someone holds a little picture and remembers the moment or life captured within it. This book takes the ubiquitous snapshot that is central to the lives of so many of us—including artists—and recognizes its varied roles, from a simple document of time and place to an evocative work of art in and of itself.

The Archives of American Art's deputy director, Liza Kirwin, conceived the theme of this book in response to the increasing attention given to snapshots in art history and popular media. Major museums have organized exhibitions around the snapshot, including *The Art of the American Snapshot, 1888–1978: From the Collection of Robert E. Jackson* at the National Gallery of Art in 2007 and *Now Is Then: Snapshots from the Maresca Collection* at the Newark Museum in 2008. In 2010 the social-networking site Instagram launched, allowing users to snap photographs comparable to Polaroid snapshots, complete with filters and borders that mimic vintage prints.

The Archives' first exploration of snapshots was the 2011 exhibition *Little Pictures, Big Lives: Snapshots from the Archives of American Art*, guest curated by photography specialist Merry Foresta, the former director of the Smithsonian Photography Initiative. Foresta adeptly framed these personal items within the history of photography, and in this book she explores the snapshot further, as it relates to a variety of themes.

Among the Archives' collections of more than twenty million items are thousands of snapshots. I have found some new favorites among the scrapbooks of art critic, artist, and teacher Suzi Gablik, who recently made a generous donation of her papers to the Archives. In them we

discover Gablik with Leo Castelli, Kenneth Noland, Anthony Caro, Claes Oldenburg, and many other famous art-world figures. But here they have stepped away from the studio or the gallery or the writing desk and are engaged in the familiar, quotidian activities that help to shape each of us—unself-conscious moments from vacations, Thanksgiving dinners, birthday parties at home. In this book you will find many similar images that offer intimate insight into the everyday lives of artists—from snapshots taken by artists just after the 1900 introduction of the Kodak Brownie camera to contemporary examples.

Through our own publications and by supporting the research of others, the Archives of American Art tells the backstory of art in America. These snapshots and the ever-growing number of letters, diaries, oral histories, and other personal and business documents preserved at the Archives are the building blocks of that backstory, adding dimension and depth to our understanding of this country's rich visual culture.

— *Kate Haw, director, Archives of American Art*

ACKNOWLEDGMENTS

Artists Unframed features snapshots selected from thousands of images scattered throughout the documents, letters, and diaries of artists in the collections of the Smithsonian Archives of American Art. These photographs invite consideration not as simple or inconsequential little pictures, but rather as complex evidence of the intimate lives of larger-than-life people.

Like all publication projects, this book was the effort of many talented individuals. My thanks go first to Kate Haw, director of the Archives of American Art, who entered this project midstream and quickly gave her blessing to our work. Liza Kirwin, the Archives' deputy director, not only provided the initial idea for a project about snapshots, but throughout was generous with her deep knowledge of and unique perspective on the rich materials held in the collections. Mary Savig, curator of manuscripts, has been more than helpful with archival research. With her enthusiasm for little pictures, she contributed not only information and access to images, but also her delightful encouragement, which was appreciated all along the way. I wish to thank, among the Archives staff who also deserve recognition for shepherding this book, Wendy Hurlock Baker, rights and reproductions coordinator; Marv Hoffmeier, digital imagist; Bettina Smith, digital projects librarian; Kathryn Donahue, intern; Susan Cary, registrar and collections manager; and Suzanne Bybee, administrative officer. I would also like to thank Jennifer N. Lippert, editorial director at Princeton Architectural Press, for her enthusiasm and guidance during a project long in the making, as well as Sara Stemen, senior editor.

Finally, my appreciation goes, as it should, to all those nameless photographers who made these snapshots and to those who saved them in shoe boxes and passed them along for us to enjoy.

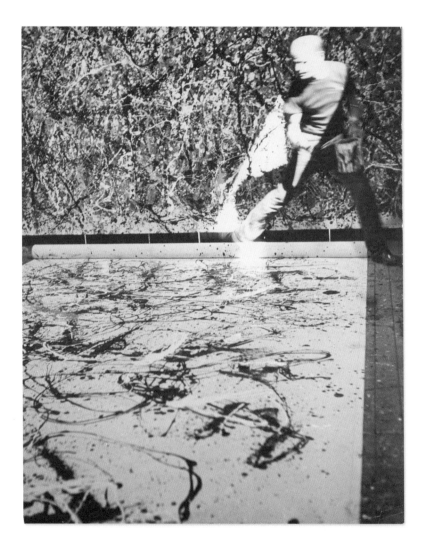

— 1950 —

Jackson Pollock in his studio in Springs, New York

PHOTOGRAPH BY HANS NAMUTH (1915 – 90)
JACKSON POLLOCK AND LEE KRASNER PAPERS, CA. 1905 – 84

INTRODUCTION

In the popular imagination, artists are romantic, exotic beings who live glamorous lives far removed from the ordinary ones the rest of us experience. This impression is reinforced by the tradition of formal portraiture staged by professional photographers for mainstream publications: artists usually pose in their studios, work tools at hand and surrounded by their art, as though the creative muse could fall upon them at any moment. Such portraits of artists paradoxically combine a sense of gravity and ephemerality, their apparent seriousness and materiality balanced against the evocation of transcendence, of expression unfettered by conventionality.

Carefully planned, these photographs once pictured artists dressed in berets and sculptor's smocks or, more recently, in denim overalls and paint-smeared work shirts. Sometimes incongruous props appear: vases of flowers, brocade tapestries, a table piled with books. The artists lean jauntily or stand heroically, staring intently at the camera or gazing out a window as if at some distant vision, all to build or conform to an image of the character we have come to know as "artist." With the rise of hand-held cameras, which replaced the portrait photographer's large studio cameras on tripods, the iconic image became an action shot, which happily coincided with the birth of action painting. We have only to give it a little thought to conjure up a mental picture of one of the images Hans Namuth made of Jackson Pollock flinging paint onto a canvas. Here is Pollock, caught by the camera in mid-gesture, his brow furrowed in the anguish of creation: the quintessential portrait of the artist in the mid-twentieth century. In our own time, learning how to present oneself to the camera has become a part of every artist's skill set.

Consider, however, another look at Jackson Pollock in photographs. Judged by the number of snapshots now in collections at the Smithsonian Archives of American Art, the Pollock family, especially the brothers

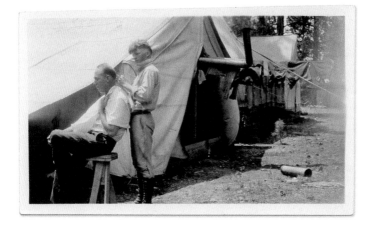

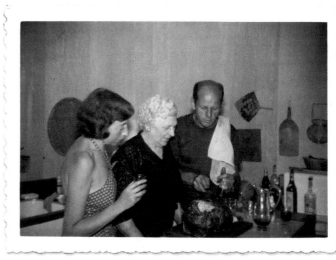

— 1927 —

**Jackson Pollock cutting the hair
of his father, LeRoy Pollock**

JACKSON POLLOCK AND LEE KRASNER PAPERS,
CA. 1905 – 84

— 1950 —

**Lee Krasner, Stella Pollock, and
Jackson Pollock carving a turkey**

JACKSON POLLOCK AND LEE KRASNER PAPERS,
CA. 1905 – 84

Jackson and Charles, must have had a camera present nearly full-time as they grew up in the western United States in the 1920s.[1] In 1945, when Jackson and his wife, the artist Lee Krasner, moved from New York City to the east end of Long Island, a camera came, too. Domestic photos of Jackson and Lee (it remains for us to guess who might have wielded the camera) are guileless and revealing, as are the images of Jackson outside his studio with his two dogs, horsing around in the backyard, or on the beach with his friends (a group that includes the influential critic Clement Greenberg and his girlfriend of the time, the painter Helen Frankenthaler). These snapshots have a backstage glamour all their own, as clear an everyday picture of the artistically famous as we might hope to have.

The early twentieth-century advent of the Kodak Brownie—considered by most historians to be the first snapshot camera—made photography accessible to a widespread public for the first time (a feat of cultural diffusion magnified many times over in our time by the introduction of smartphone digital cameras). In the parlance of vintage Kodak advertising: you pressed the button, and they did the rest. Formal portraits taken by professionals were supplemented in the vaults of memory by family albums filled with snapshots taken by untrained but earnest hobbyists. As photography became more and more an everyday activity, everything and anything became a worthy target for the camera. By the middle of the twentieth century, amateurs began to see their picture taking as a way not only to document themselves and their families, as well as the places and things most important to them, but also to define and even transform themselves. For artists it was the same.

There is no question that snapshots can be compelling and complex, even unintentionally. After years of being neglected by historians of photography, snapshot images have become objects of aesthetic fascination, cultural nostalgia, and critical discourse. In our digital age they have been the focus of a number of substantial publications and exhibitions.[2] The postures we adopt, the gestures we pantomime, the

camera's odd tilts, and the images' arbitrary croppings—all are part of what has become known as the "snapshot aesthetic."[3] These images are both familiar in format (most of us have snapshots of one kind or another tucked away) and alien in content (while we might recognize the conventional pose of a family gathered around the picnic table on the Fourth of July, the faces are unfamiliar). They provide historical access—if not always factual—to cultural, political, and social trends (the rise of the middle-class family and outdoor recreation, say), while they encourage the viewer to construct a story to describe the people or events in the picture (why was that little girl on the left crying?).

The mostly casual, unassuming snapshots in the collections of the Archives of American Art offer a special genre of artist portrait, as well as (for those involved in charting art history) surprising insights into artists' personal lives. They depict families, friends, and lovers. They picture celebrations and parties that mark proud public moments and intimate private ones. They show artists being silly, thoughtful, and showing off. With them we visit the world of studios and galleries. We know the identities of these pictures' subjects and often where the images were made, which is frequently not the case with the snapshots in our own family albums. Armed with such information, we use the lens of retrospection to consider these subjects in the context of what happened later, long after the snapshot was made. Snapshots offer entry into the biographies of artists.

The photographs selected for this book—most from the golden age of film-and-paper snapshots, the 1920s through the 1960s—include those taken informally by artists in the company of other artists, in their studios, and at events that give us a sense of the art world of previous generations. These photographs, rich in connections and implications, might find their way into art-history texts in the future.

This book is loosely arranged around four themes, assigned to four chapters, "Work," "Play," "Family & Friends," and "This is Me!," based upon the various situations and impulses common to the images.

"Work" captures artists in unguarded moments in their studios, outdoors at their easels, at the art colony. Or at the art gallery, where the activity of openings—artistic work of a certain sort—and the boisterous celebrations that follow are frequently captured by the camera. These unguarded moments give us a real, if brief, look at the artistic process.

The snapshots in "Play" provide rare glimpses of what artists did in the privacy of their homes and how they played when they were away. Through these images, the lives of artists become available to us. For a moment, we feel connected to these people and their lives, which are not so different from ours.

The snapshots in "Family & Friends" emphasize a narrative about connection, community, and interaction. Recording the family for posterity is one of the most common motives of snapshot photography. Kodak advertisements from the early twentieth century stressed photography as a means to record activities and moments of family togetherness and to counter the failure of memory.[4] Just like the rest of us, artists have filled their family albums with images of children, vacations, and the gatherings of friends and relatives for celebrations. Perhaps these are particularly valuable for artists, who so often live in a peripatetic world: snapshots are a way of creating stability through the memories they hold. From artists, however, the sentimental forget-me-not messages of ordinary snapshots often are more like a "Here I am!" declaration. What matters is the documentation of the occasion; the picture-taking act itself has become a part of the ritual of meeting and greeting.

Every photograph marks an instant in time. It both confirms and recalls the reality of that moment. It declares on behalf of both photographer and subject, "This is me!" The images in the fourth and final section embody those messages, from Ansel Adams's forthright Photomatic self-portrait to early snapshots of the abstract expressionists, which provide fresh views of their then-new and radical work. In the extensive snapshot archives of gallerists Colin de Land and Pat Hearn, we trace day-to-day details that combine to form visual diaries not only

of the couple's personal lives, but also of an entire artistic community. Their self-conscious and insistent use of a camera comes close to being a conceptual art project.

In the hundred years this survey encompasses, snapshots have gone from novelties documenting the experience of a fortunate few to the currency of everyday experience, now omnipresent and inescapable in the form of smartphone photos, circulated almost at the moment they are made—sped-up Polaroids for the digital age. Snapshots have transformed from signs of artists' common humanity to part and parcel of what art is and what artists are. What has stayed the same through all this change is the beguiling charm of the pictures themselves: whether they represent offhand moments or implicate artistic intention, the snapshots you are about to see have a purchase on the viewer's imagination that simply won't go away.

1. Several family collections contain Pollock family snapshots: see the Charles Pollock Papers, 1902–90; Jackson Pollock and Lee Krasner Papers, circa 1905–84.

2. This book is based on the exhibition *Little Pictures, Big Lives: Snapshots from the Smithsonian Archives of American Art*, July 1 – September 31, 2011. A list of recent books and exhibitions about the history and culture of the snapshot includes: Thomas Walther and Mia Fineman, *Other Pictures: Anonymous Photographs from the Thomas Walther Collection* (New York: The Metropolitan Museum of Art, 2000); Sarah Greenough and Diane Waggoner with Sarah Kennel and Matthew S. Witkovsky, *The Art of the American Snapshot, 1888–1978* (Washington, D.C.: National Gallery of Art, 2007); Marvin Heiferman, Nancy Martha West, Geoffrey Batchen, *Now Is Then: Snapshots from the Maresca Collection* (New York: Princeton Architectural Press, 2008); Elizabeth W. Easton, ed., *Snapshot: Painters and Photography, Bonnard to Vuillard* (New Haven, CT: Yale University Press, 2011); and Catherine Zuromskis, *Snapshot Photography: The Lives of Images* (Cambridge, MA: The MIT Press, 2013).

3. John Szarkowski uses this phrase in discussing the work of Garry Winogrand. John Szarkowski and Garry Winogrand, *Winogrand: Figments from the Real World* (New York: Museum of Modern Art, 1988). According to Matthew S. Witkovsky, writing in *The Art of the American Snapshot*, the origins of the term in literature of the mid-1960s have yet to be pinpointed (288).

4. For a full discussion of the role of Kodak advertisements and the development of snapshot culture, see Sarah Kennel, "Quick, Casual, Modern: 1920–1939," in *The Art of the American Snapshot*.

WORK

T wo early twentieth-century studio photos made in a casual, snapshot style describe the interests of Allen Tupper True (1881–1955) and Newell Convers (N. C.) Wyeth (1882–1945), fellow students of Howard Pyle at his Wilmington, Delaware, school of illustration. The romance of the West inspired both young men. Their studios were full of cowboy costumes and Native American artifacts, many of which wound up as details in their paintings and drawings. Wyeth, who was best known as an illustrator of American subjects for magazines such as the *Saturday Evening Post*, even worked for a time as a cowboy, returning east with cowboy costumes and Native American artifacts to feature in his work. True, who became a mural painter, specialized throughout his career in Western themes.

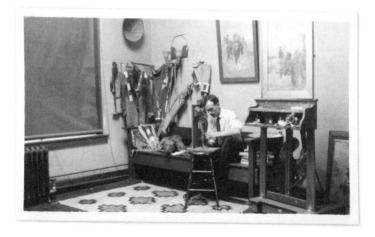

— CA. 1901 —

Allen Tupper True in his Delaware studio

ALLEN TUPPER TRUE AND TRUE FAMILY PAPERS, 1841 – 1987

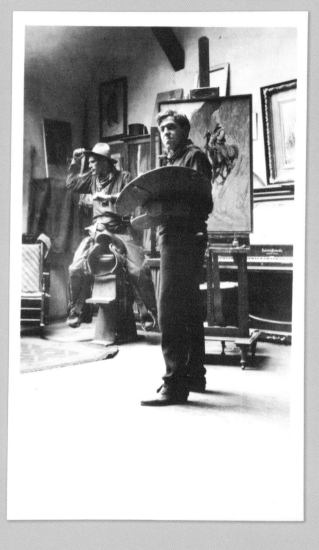

— CA. 1905 —

N. C. Wyeth in his Delaware studio with Allen Tupper True modeling as a cowboy

ALLEN TUPPER TRUE AND TRUE FAMILY PAPERS, 1841–1987

This spontaneously posed picture shows the painter Andrew Dasburg (1887–1979, left); an unidentified visitor; and possibly Roland Moser (right), Dasburg's studio mate, cleaning dishes after a meal in Dasburg's Paris studio, at 115 rue Notre Dame des Champs. The image suggests the makeshift life of an American artist in Paris circa 1910. Like many aspiring American painters, Dasburg sought out experience in the then-capital of the art world. In fact it was a return home for Dasburg, who was born in France and taken to the United States as a young child. Returning to New York City after only one year, Dasburg became prominent in New York art circles and was among the youngest artists to exhibit at the International Exhibition of Modern Art in 1913. He also showed his work at Alfred Stieglitz's 291 gallery. In 1916 he made the first of many visits to Taos, New Mexico, settling there permanently in 1930.

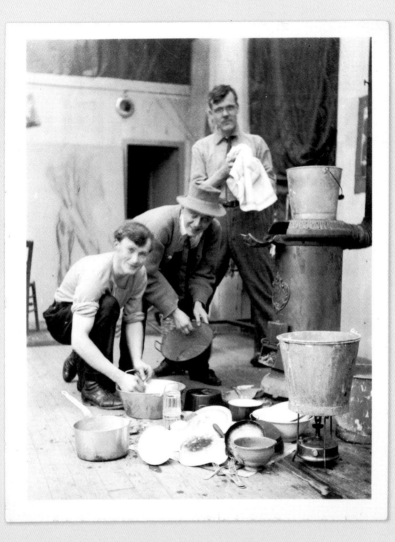

Andrew Dasburg's Paris studio

<small>ANDREW DASBURG AND GRACE MOTT JOHNSON PAPERS, 1833–1980</small>

Presenting objects for a camera is something all of us do. Usually these objects are a source of pride—a shiny new car, the big house we just bought, the treasure we just found at the flea market. Think, too, of all the snapshots of new babies held up for the camera by proud parents. Artists' most prized possessions are usually their own artwork; sometimes they relate to their creations as if they were their children. Sometimes the artwork is a performance of the self that is put on show for the camera, a visual reminder of the artist's presence.

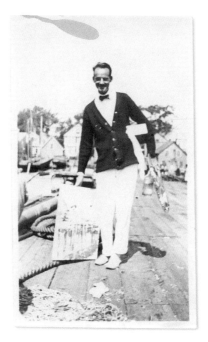

— CA. 1910 —

John Robinson Frazier carrying a painting

John Robinson Frazier (1889 – 1966) was a painter, illustrator, and art school administrator.
He served as president of the Rhode Island School of Design from 1955 to 1962.
JOHN ROBINSON FRAZIER PAPERS, 1920 – 69

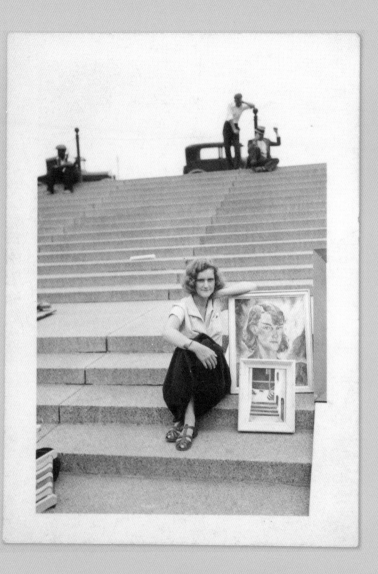

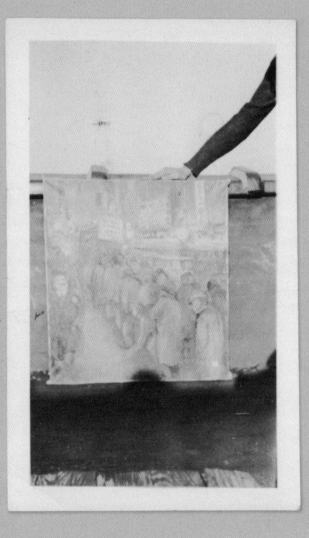

James Penney holding a painting on a roof

James Penney (1910–82) was a landscape painter, muralist,
and educator who taught at Hamilton College from 1948 to 1976.
JAMES PENNEY PAPERS, 1913–84

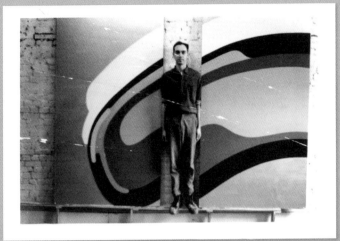

— NOV. 1963 —

Robert Mangold in his New York studio

Robert Mangold (b. 1937) is a painter best known for
minimalist, abstract works of architectural scale.
FISCHBACH GALLERY RECORDS, 1937–77

— CA. 2000 —

**Unidentified individual
holding a Polaroid**

COLIN DE LAND COLLECTION, 1968–2008

The majority of snapshots worth saving combine good intentions and good luck with engaging subjects. Most of the time, we can never know exactly what occasioned their making. The unguarded moments snapshots reveal of artists at work in their studios, outdoors at their easels, or teaching give us behind-the-scenes glimpses of the artistic activity that some may call work and others play; in the best instances, snapshots tell us something about both the artist and the art.

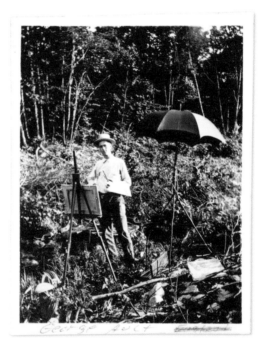

— CA. 1920 —

George Ault painting outdoors

George Ault (1891 – 1948) was an American painter whose style was shaped by his interest in a curious mix of the avant-garde, realism, and folk art.
GEORGE AULT PAPERS, 1892 – 1980

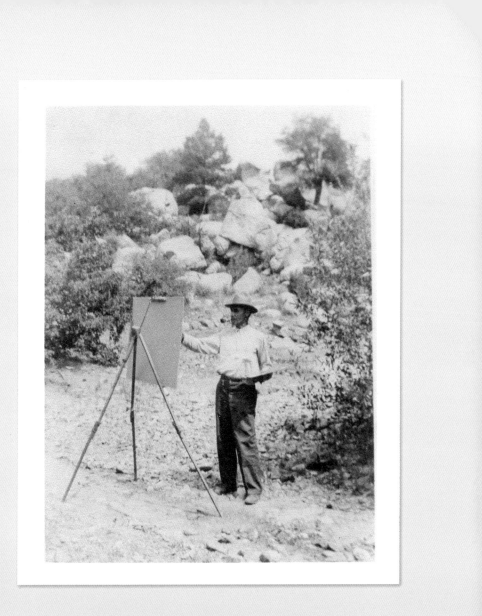

I n 1932 Grant Wood (1891–1942), Edward Beatty Rowan (1898–1946), and Adrian Dornbush (1900–1970) founded the Stone City Art Colony near Cedar Rapids, Iowa. With little more than a hundred dollars they leased ten acres of land, which included buildings for sculpture and painting studios. For living quarters, the camp boasted wooden icehouse wagons, many of which were imaginatively decorated by the artists. The colony lasted only two years—perhaps the wagon arrangements had something to do with this—but Stone City, led by Wood, still assembled a distinguished and enthusiastic population.

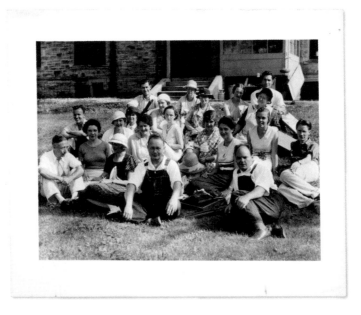

— 1933 —

Students and faculty at the Stone City Art Colony

Grant Wood and John Steuart Curry (1897 – 1946) are in the front row.
Edward Beatty Rowan Papers, 1929 – 46

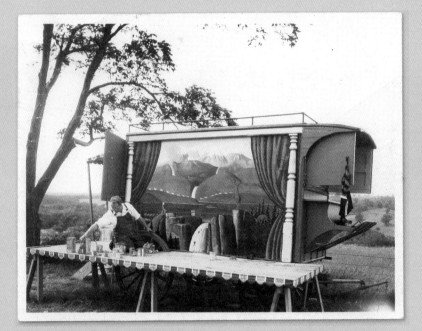

Grant Wood putting the finishing touches on his ice wagon

EDWARD BEATTY ROWAN PAPERS, 1929–46

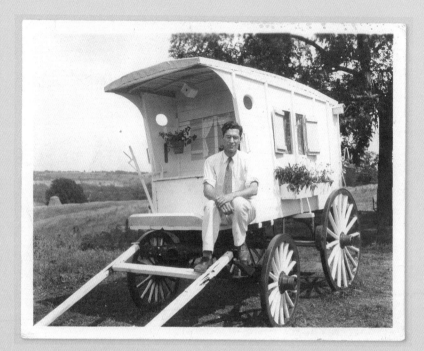

Edward Beatty Rowan seated on a wagon

EDWARD BEATTY ROWAN PAPERS, 1929–46

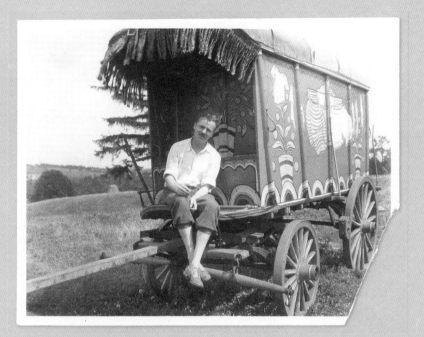

Born in Japan, painter Yasuo Kuniyoshi (1893–1953) immigrated to America in 1906, stopping first in California and then moving east to attend the Art Students League of New York, where he would also become a teacher. To supplement his income he did commercial photography—mostly shooting artwork for galleries and catalogs. He moved to the Woodstock art colony with his first wife, artist Katherine Schmidt, in 1927. They built a house and enjoyed the relaxed community of artists. His friend and Woodstock neighbor, painter and photographer Konrad Cramer (1888–1963), also shot his friends' artwork and commissioned portraits, as well as informal photographs such as this one of a smiling Kuniyoshi. No photograph of Cramer by Kuniyoshi can be found, but perhaps the two were enjoying an afternoon of photography, taking turns as subject and photographer.

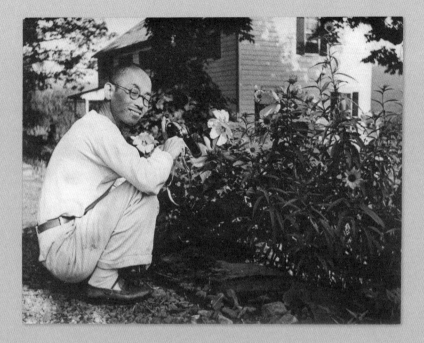

Yasuo Kuniyoshi taking photographs

PHOTOGRAPH BY KONRAD CRAMER
KONRAD AND FLORENCE BALLIN CRAMER PAPERS, 1897–1968

The tilt of this lively picture mimics the motion of a Calder mobile in space. Agnes Rindge Claflin (1900–1977), the author of an authoritative book on sculpture published in 1929, was an art historian at Vassar College and had just been named director of the Vassar College Art Gallery when she visited her friend Alexander Calder (1898–1976) in his studio at the Calder farmhouse in Roxbury, Connecticut. The mid-1940s were an important time for both the scholar and the artist. In 1943 Claflin became an assistant executive vice president of the Museum of Modern Art. In the same year the museum organized an exhibition of Calder's sculpture, a project that included a film, *Alexander Calder: Sculpture and Constructions*, written and narrated by Claflin. Could the push she seems to have just given the mobile be something of a test for her film project?

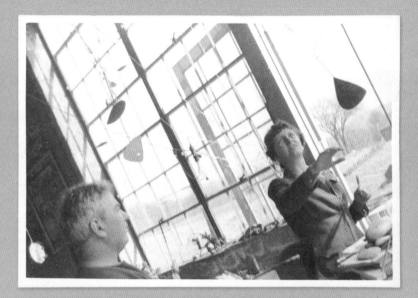

— CA. 1942 —

**Alexander Calder and Agnes Rindge Claflin
in Calder's studio in Roxbury, Connecticut**

AGNES RINDGE CLAFLIN PAPERS CONCERNING ALEXANDER CALDER, 1936–CA. 1970S

In the aftermath of World War II, even as the art world's center shifted from Paris to New York, students and artists such as Esther Rolick (1922–2008) descended on Paris and the art capitals of Europe in search of inspiration and a connection to the past. They were also motivated by a sense of nostalgia for the experiences and achievements of the Lost Generation of the 1920s, which had been drawn to the Old World's tolerance for experimentation and artistic freedom. After Rolick's return to New York, her work appeared in exhibitions that included a one-person show at the Jacques Seligmann & Co. gallery in 1953. And, perhaps most importantly, she taught art, imparting the joys of artistic freedom to young American artists. Her course "Black Music and Art," taught at Mercy College in Dobbs Ferry, New York, in the early 1970s, was full of insights she gleaned from interviews she conducted with a generation of African American artists.

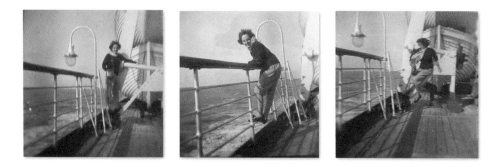

— SEPT. 1948 —

Esther Rolick on board the SS *Saturnia*

On the backs of these three snapshots, Esther Rolick wrote: "My first trip to Europe."
How many American artists were thrilled to be able to make this simple claim?
ESTHER G. ROLICK PAPERS, 1941–85

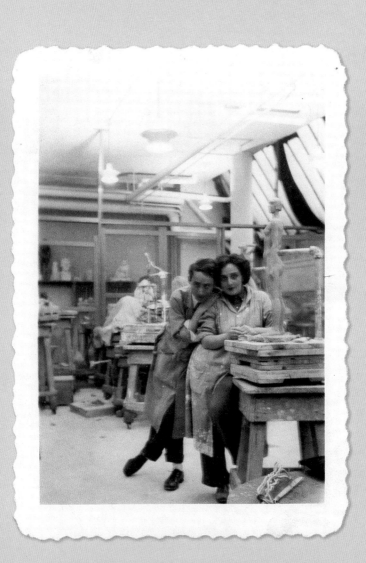

— 1945 —

Sculptor Wessell Couzijn and Esther Rolick in Rolick's New York studio

During World War II, the studio of painter Esther Rolick was a sanctuary for artists such as sculptor
Wessell Couzijn (1912–84), who had been forced to flee Europe by the Nazis.
ESTHER G. ROLICK PAPERS, 1941–85

What a wonderful moment: Elaine de Kooning (1918–89) holding forth at the center of a circle of male artists during a 1956 opening at the Tanager Gallery in New York City. Maybe the conversation was about her inclusion that year in the Museum of Modern Art's exhibition *Young American Painters*, an event that certainly marked her as one of the boys. The Tanager, which operated on East Tenth Street from 1952 to 1962, was among the group known as the Tenth Street Galleries, a community of artist-run, generally low-budget galleries and studios that opened and closed throughout the 1950s and '60s. Making exhibition space available to a wide range of painters and sculptors, with a number of older, more established artists such as de Kooning's husband, Willem de Kooning; Franz Kline; and Milton Resnick as neighbors in nearby studios, these venues were an avant-garde alternative to the more conservative uptown galleries. Then, as now, artists' neighborhoods such as Tenth Street were places to meet and mingle. Evening openings were a mix of famous and not-so-famous artists, poets, writers, curators, and collectors.

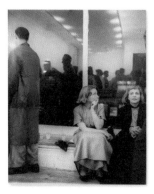

— CA. 1952 —

Tanager Gallery opening

PHOTOGRAPH BY MAURICE BEREZOV (1902 – 89)
TANAGER GALLERY RECORDS, 1952 - 79

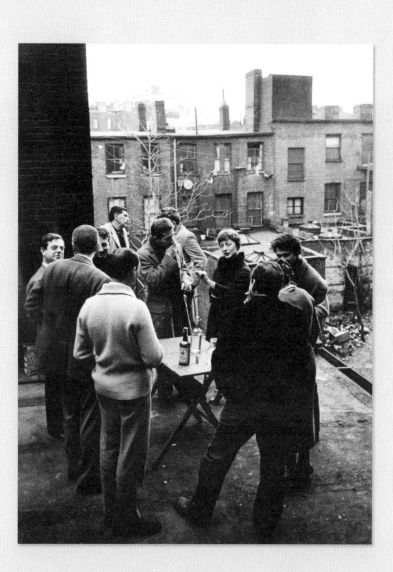

— 1956 —

Gathering on the roof of the Tanager Gallery

JOELLEN BARD'S, RUTH FORTEL'S, AND HELEN THOMAS'S EXHIBITION RECORDS
OF "TENTH STREET DAYS: THE CO-OPS OF THE 50S," 1953–77

The name Edith Gregor Halpert (1900–1970) figures prominently on the résumé of many of the most important American artists of the twentieth century. From the late 1920s through the 1960s, her Greenwich Village establishment, the Downtown Gallery, introduced or showcased such contemporary and future art stars as Stuart Davis, Georgia O'Keeffe, Arthur Dove, Jacob Lawrence, Charles Sheeler, Yasuo Kuniyoshi, and Ben Shahn. She was brilliant at using marketing and advertising to get her artists included in museum exhibitions and public collections. As one brochure stated, the Downtown Gallery had "no prejudice for any one school. Its selection is driven by quality—by what is enduring—not by what is in vogue." By the mid-1960s, when this snapshot of an exultant Halpert was taken, exhibitions of modern American art from her collection were touring throughout the United States and Europe.

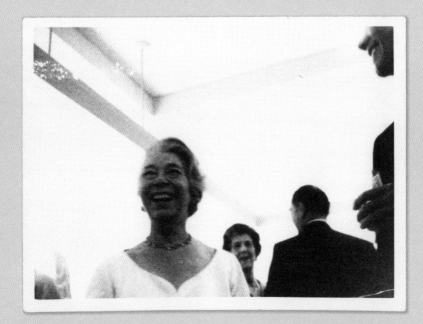

Una Hanbury (1904–90) was born in England. After World War II she and her family moved to the United States, first settling in Washington, D.C., and then moving to Santa Fe, New Mexico, where she maintained a studio until her death. She used a variety of materials for her work, but she is best known for bronze portrait busts. Hanbury must have had a way of charming famously difficult people. Though she would not move permanently to Santa Fe until 1970 and most likely had not previously known America's most famous—and most notoriously reclusive—woman artist, the relaxed pose of the sitter and the casual attire of the sculptor depicted in this photo suggest an afternoon spent on the patio in easy conversation between two old friends. Whatever transpired, the result was a cast bronze portrait bust of Georgia O'Keeffe (1887–1986) now in the Smithsonian's National Portrait Gallery.

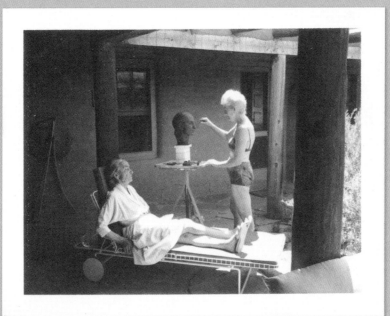

Una Hanbury sculpting a bust of Georgia O'Keeffe

UNA HANBURY PAPERS, 1910–94

Painter Honoré Sharrer (1927–2002), whose colorful, realistic paintings documented the daily experiences of ordinary working people, often used the camera to collect images for her paintings. Over many years she made hundreds of snapshots of people, animals, and architectural details and kept them in white envelopes labeled by subject, such as "Dogs," "Teenage Boys," and "Cars." She often asked her subjects to strike particular poses or wear particular costumes, and many of these figures can be found reproduced exactly in her paintings. In later years, her husband, historian and University of Virginia Professor Perez Zagorin (1920–2009), was often Sharrer's model in her makeshift photo studio.

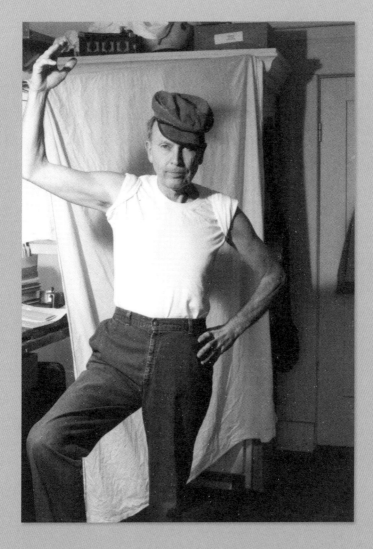

— DEC. 1984 —

Perez Zagorin posing for *Roman Landscape*

PHOTOGRAPH BY HONORÉ SHARRER
HONORÉ SHARRER PAPERS, CA. 1927 – 2002

PLAY

A snapshot album dated 1912 records the idyllic summer vacation of painter and exhibition organizer Walt Kuhn (1877–1949) and his family in Nova Scotia, Canada. Photographs in the album are arranged in various combinations of people, places, and events. Casual family portraits, baby pictures, and picnic scenes mingle with snapshots of Nova Scotia lighthouses and well-known island locations such as Woods Harbour. Some images are annotated, giving clues to an overall narrative of relaxed family time in an unfamiliar natural setting. One snapshot of Kuhn at work at an outdoor easel is captioned "Study in Triangles," suggesting a lighthearted take on the artistic elements of the photo and on the form of the painting in progress. For Kuhn, one of four artists who in 1911 founded the Association of American Painters and Sculptors, an advocacy group supporting modern American artists, the summer of 1912 must have been a respite from the previous months of planning the new artist organization. Kuhn was soon to embark on several months of European travel in pursuit of works for an enormous upcoming show of contemporary art, the International Exhibition of Modern Art. Kuhn and his associates, Arthur B. Davies and Walter Pach in particular, had a big ambition: to expose New Yorkers—artists and nonartists alike—to the most avant-garde art to be found in Europe. The exhibition, which was on view from February 17 to March 15, 1913, and has become known as the Armory Show, was the first international exhibition of modern art in the United States.

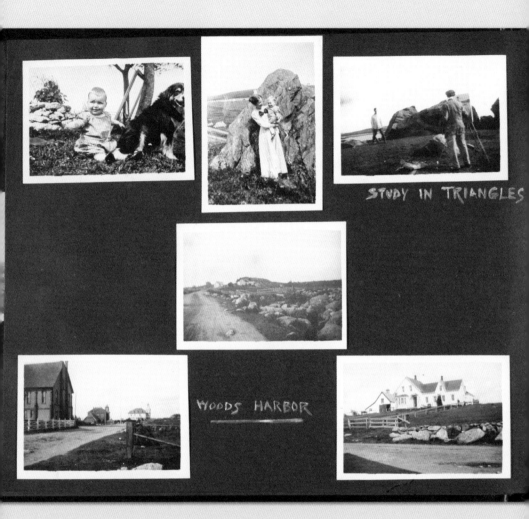

STUDY IN TRIANGLES

WOODS HARBOR

— 1912 —

Walt Kuhn, family photograph album including "Study in Triangles"

WALT KUHN, KUHN FAMILY PAPERS AND ARMORY SHOW RECORDS, 1859–1978

Written on the back of this snapshot is "Coytesville Bolero, Albrig's Pavillion, Fort Lee, N.J." Imagine a summer-afternoon reunion of three old friends enjoying the fresh air at an amusement park, some homegrown music, and some energetic dancing. At the turn of the last century, the northern New Jersey towns of Fort Lee, Coytesville, and Ridgefield could all boast art colonies with a mix of artists, illustrators, and musicians. Pop Hart (1868–1933), dancing the imaginative bolero and playing bones, Walt Kuhn, playing the guitar, and Gus Mager (1878–1956), playing the banjo, had previously lived in Fort Lee, each individually and sometimes together. Perhaps it was cartoonist Mager, who lived in nearby Newark, who got them together for a day on the Coytesville boardwalk. Or perhaps Pop Hart (his real name was George Overbury) was the organizer, taking a day off from working on set designs for Fort Lee's fledgling movie industry. Likely, Kuhn, famous as one of the organizers of the Armory Show, was the guest of honor.

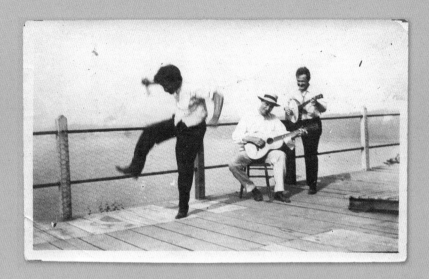

Now collected at the Archives of American Art, the papers of Rockwell Kent (1882–1971) are a testament to the many aspects of his life. He was variously an architect, draftsman, carpenter, unskilled laborer, painter, illustrator, printmaker, commercial artist, designer, writer, professional lecturer, dairy farmer, and political activist. Kent was also an avid traveler. He was particularly fond of expeditions to the Arctic, where he often stayed for long periods of time to paint, write, and become, even briefly, one of the locals. The Alaska snapshot is a souvenir of his 1918–19 trip with his ten-year-old son, Rocky. His letters home (later published in the book *Wilderness: A Journal of Quiet Adventure in Alaska*) present a more thoughtful series of recollections. Further dramatic adventures are described in his 1930 memoir, *N by E*, a description of a summer 1929 voyage with his then-wife Frances, which included the adventure of a shipwreck on the rocks of Greenland.

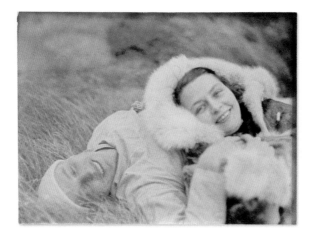

— CA. 1930 —

Rockwell Kent and Frances Kent in Greenland

ROCKWELL KENT PAPERS, CA. 1840 – 1993

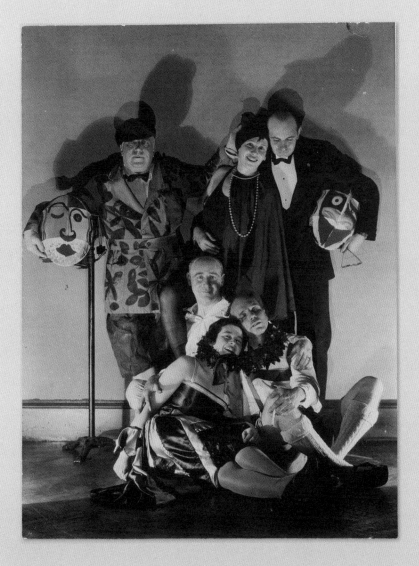

— CA. 1930 —

Rockwell Kent (bottom right) and others dressed for a costume party

ROCKWELL KENT PAPERS, CA. 1840 – 1993

55

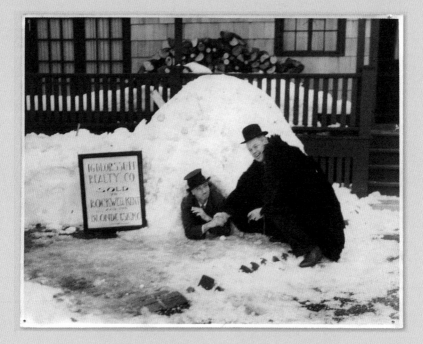

Rockwell Kent (left) in Alaska

ROCKWELL KENT PAPERS, CA. 1840–1993

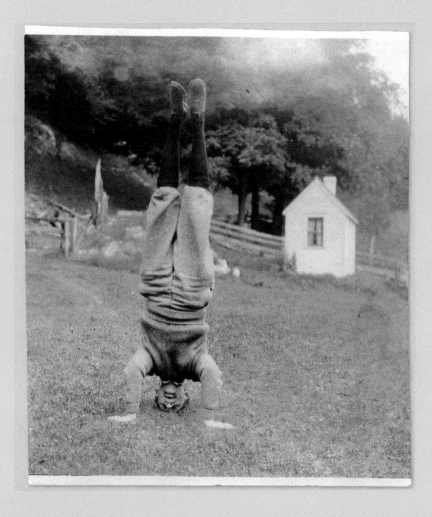

Social, engaging, and extroverted, Prentiss Taylor (1907–91) was a lithographer, painter, and teacher. He studied painting with Charles W. Hawthorne at his Cape Cod School of Art in Provincetown, Massachusetts, but his talents were mostly realized as a printmaker. By the mid-1920s, the time period covered by Taylor's snapshot albums, the "oldest and most picturesque hamlet on the New England Coast" (as Provincetown was described by Hawthorne's school brochure) had become a magnet for young artists, writers, and musicians, some coming for the summer season, others moving to the Cape permanently. This group of high-spirited bohemians with a newfound sense of artistic, political, and sexual freedom included writers and musicians as well as visual artists. Taylor's snapshots show a joyous jumble of young students enjoying summer, participating in amateur theatrics, sketching in the dunes, and dancing on the beach. A snapshot of Taylor himself lounging at the beach is at the head of a page captioned "All August + all Provincetown 1924."

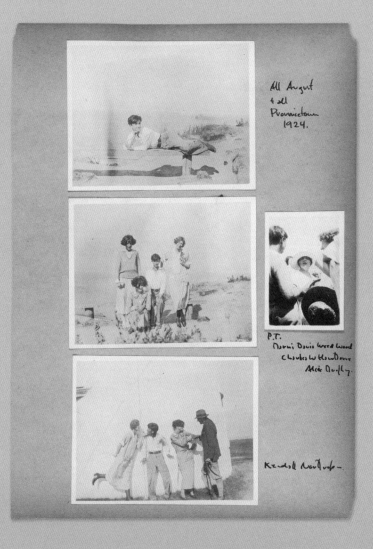

All August
+ all
Provincetown
1924.

P.T.
Naomi Davis Wood Wood
Charles W. Henderson
Alice Dunfly.

Kendall Northrop.

— AUG. 1924 —

Prentiss Taylor, photograph album of friends and family in Provincetown, Massachusetts

Prentiss Taylor Papers, 1885–1991

Reginald Marsh (1898–1954) was a painter, illustrator, and print-maker best known for his scenes of vaudeville halls, nightclubs, burlesque shows, and New York City streets. After his divorce from sculptor Betty Burroughs in 1933, he married painter Felicia Meyer (1912–78), the daughter of painter Herbert Meyer, in 1934. This picture has all the ingredients of a treasured family snapshot: a sunny afternoon, a roadside picnic, a happy couple. As with most photos, the details of its why and where are lost to us. We might guess that the picnickers were on the journey between New York City and the Marshes' home in Vermont, and that the couple, all smiles, knew the person who held the camera.

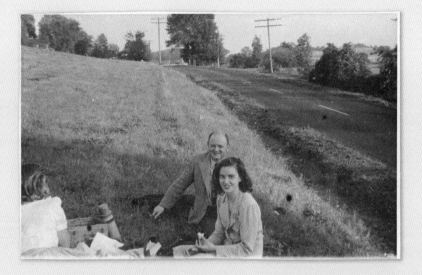

British author E. M. Forster (1879–1970) was nearly seventy and a celebrity when this charming snapshot was made. His novels, among them *A Room with a View* (1908) and *A Passage to India* (1924), examine class and cultural difference and hypocrisy in the early years of the twentieth century; they were avidly read on both sides of the Atlantic. This photo, saved in the Papers of George Tooker (1920–2011), was most likely made during a 1947 gathering at the summer house of Jared and Margaret French in Provincetown, Massachusetts. We don't know if Tooker, then a twenty-seven-year-old aspiring painter, took the photo or was there when the picture was made or if his lover at the time, artist Paul Cadmus, brought it back as a souvenir. It was a complicated vacation household: Cadmus was also Jared French's lover while the latter was married to Margaret. If Tooker was present, he was part of an ongoing summer-long party that might at any time include other artists, poets, and writers, such as dance critic and cultural impresario Lincoln Kirstein, who within a few years became Tooker's most important champion.

Art student and fashion correspondent Bettina Bedwell (1889–1947) and painter and printmaker Abraham Rattner (1893–1978) met in the early 1920s in Paris, where they were part of the post–World War I culture of expatriate writers and poets. They married in 1924, returning to New York in 1939.

Among the hundreds of travel and family snapshots in the Rattner Papers are these, documenting a cross-country road trip from California to New York City, which Rattner and Bedwell made in 1947 with their friends Arnaud d'Usseau (1916–90), a playwright and Hollywood film writer, and his wife, Suzie. Their black-and-white and color photos depict friends and family they visited and scenes along the road, often taken from the car. Many of the snapshots were left as strips of images and later pasted into albums; as such, they seem to mimic a travel movie. Rattner annotated the images with a running commentary of where and when they were made, creating a unique document of post–World War II America. These photos also mark a happy adventure that preceded a tragic loss: shortly after arriving in New York, Bedwell died suddenly of a kidney infection, sending Rattner into a spiral of grief and depression.

— NOV. 20, 1946 —

Abraham Rattner, Bettina Bedwell, Arnaud d'Usseau, and Suzie d'Usseau

ABRAHAM RATTNER AND ESTHER GENTLE PAPERS, 1891–1986

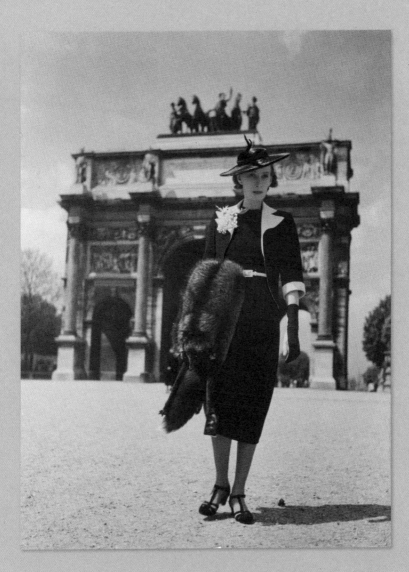

— CA. 1937 —

Bettina Bedwell in the Tuileries Garden, Paris

ABRAHAM RATTNER AND ESTHER GENTLE PAPERS, 1891–1986

Film K-1 - 1947
1947.
CROSS-COUNTRY TRIP WITH D'USSEAU
armand and Suzie d'Usseau.
from Nevada City Calif. to N.Y.C.
July 20th (Sunday) to July 27th (Sunday)
we met first on the 17th at Mr. David Lamson's
at Nevada City (Grass Valley).

K-1 1947 K-1 1947

— 1947 —

**Abraham Rattner and Bettina Bedwell, photograph album
of cross-country road trip**

Abraham Rattner and Esther Gentle Papers, 1891–1986

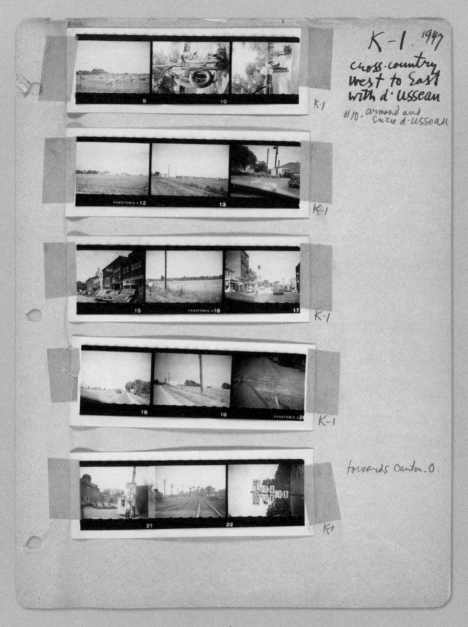

K-1. 1947
cross-country
west to East
with d'ussean
#10- armand and
suzie d'ussean

K-1

K-1

K-1

K-1

towards Canton - O.

K-1

On October 25, 1945, Jackson Pollock (1912–56) and Lee Krasner (1908–84) married and moved from New York City to the country. Art patroness and gallerist Peggy Guggenheim loaned the couple the money to purchase a small piece of property overlooking Accabonac Creek in Springs, a village near East Hampton, Long Island. At first, both Krasner and Pollock created studios in the house: Krasner in the back parlor and Pollock in an unheated bedroom. The next summer Pollock moved his studio to the barn. There he developed his mature style, pouring and dripping paint onto large canvases. Krasner was a fierce advocate for Pollock's art. She kept him at work and enticed a circle of critics and curators to gather around them both in the city and in the country. After Pollock's death in August 1956, Krasner kept the Springs house and eventually moved her studio into the barn.

These summertime snapshots reveal intimate and relaxed moments in their passionate, sometimes tempestuous, often competitive relationship: Krasner and Pollock at the beach in East Hampton, alone or in the company of friends such as Clement Greenberg (1909–94) and Helen Frankenthaler (1928–2011), or at summer-afternoon gatherings in the backyard or studio.

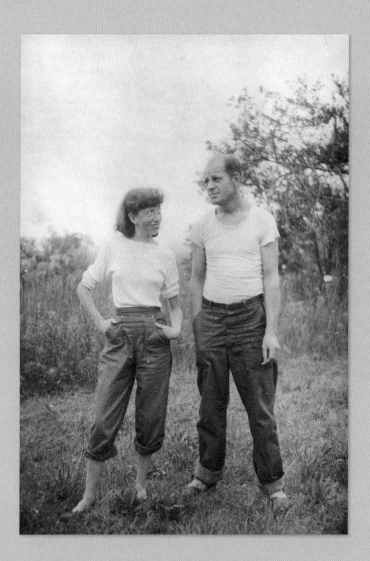

— CA. 1946 —

Lee Krasner and Jackson Pollock

PHOTOGRAPH BY RONALD STEIN (1930 – 2000)
JACKSON POLLOCK AND LEE KRASNER PAPERS, CA. 1905 – 84

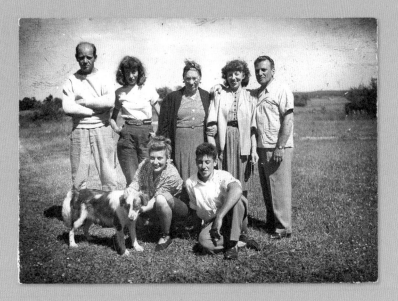

Jackson Pollock and Lee Krasner with Krasner's family

Front row: Lee's niece Muriel Stein with Pollock and Krasner's dog, Gyp, and nephew Ronald Stein.
Back row: Pollock, Krasner, Krasner's mother, Anna Krassner; sister, Ruth Stein; and Ruth's husband, William Stein
JACKSON POLLOCK AND LEE KRASNER PAPERS, CA. 1905 – 84

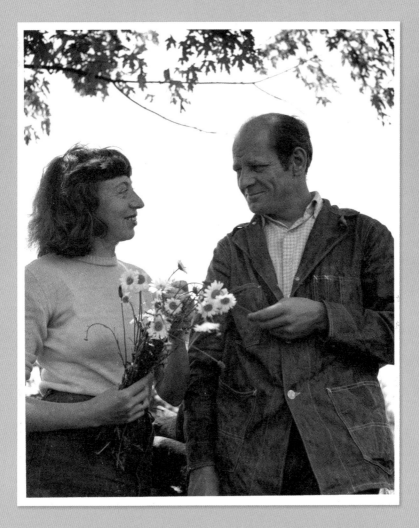

— CA. 1949 —

Lee Krasner and Jackson Pollock

PHOTOGRAPH BY WILFRID ZOGBAUM (1915 – 65)
JACKSON POLLOCK AND LEE KRASNER PAPERS, CA. 1905 – 84

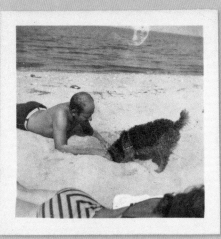

Jackson Pollock on the beach with a dog

JACKSON POLLOCK AND LEE KRASNER PAPERS,
CA. 1905 – 84

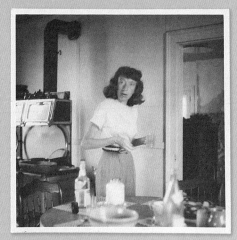

— 1948 —

**Lee Krasner in the kitchen,
Springs, New York**

JACKSON POLLOCK AND LEE KRASNER PAPERS,
CA. 1905 – 84

72

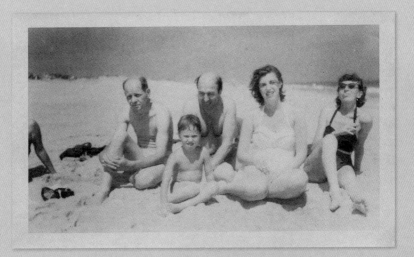

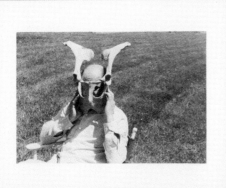

— CA. 1950 —

**Jackson Pollock posing with animal
bones in Springs, New York**

JACKSON POLLOCK AND LEE KRASNER PAPERS,
CA. 1905 – 84

— JUL. 1952 —

**Jackson Pollock, Clement Greenberg,
Helen Frankenthaler, Lee Krasner,
and an unidentified child at the beach
in East Hampton, New York**

JACKSON POLLOCK AND LEE KRASNER PAPERS,
CA. 1905 – 84

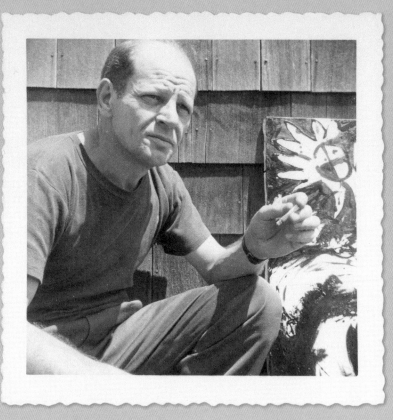

**Jackson Pollock outside his studio in Springs, New York,
with his painting *Number 9, 1952: Black, White, Tan***

JACKSON POLLOCK AND LEE KRASNER PAPERS, CA. 1905–84

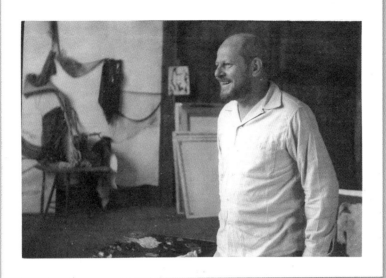

Jackson Pollock in his studio

JACKSON POLLOCK AND LEE KRASNER PAPERS, CA. 1905–84

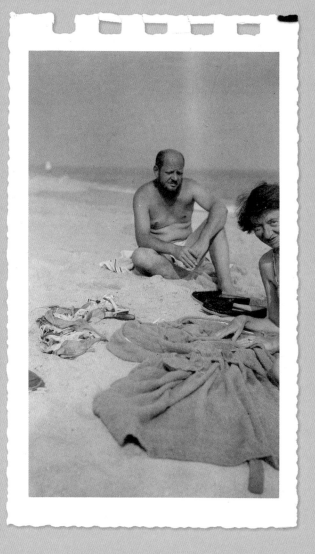

— 1955 —

Jackson Pollock and Lee Krasner at the beach in East Hampton, New York

JACKSON POLLOCK AND LEE KRASNER PAPERS, CA. 1905–84

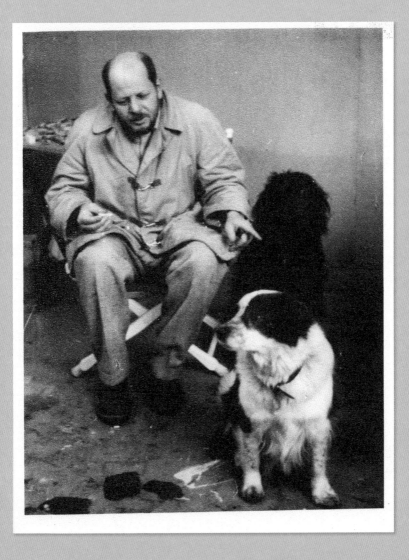

Jackson Pollock in the studio with his dogs Ahab and Gyp

JACKSON POLLOCK AND LEE KRASNER PAPERS, CA. 1905 – 84

By the time these artists shared a weekend at the country house of Oliver Jennings in the Snedens Landing neighborhood of Palisades, New York (on the other side of the Hudson just north of New York City), George Tooker had already established his reputation as one of the most important artists of his generation. It looks like quite a costume party and presents a surprising side of an artist who was in that period known for haunting images that exemplified twentieth-century anxiety and alienation. This snapshot comes from the papers of William Christopher (1924–73), who would remain Tooker's lifelong partner until Christopher's death.

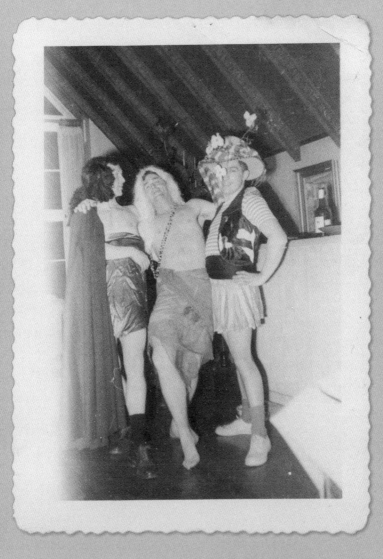

— CA. 1951 —

George Tooker, Daniel Maloney, and William Christopher

WILLIAM CHRISTOPHER PAPERS, 1946–72

A native of California, painter and photographer Harry Bowden (1907–65) studied art in Los Angeles and New York. Although he continued to show his paintings in New York galleries, following World War II Sausalito became his permanent home. He also began to concentrate on photography. An admirer of Edward Weston, about whom he made an unfinished film called *Wildcat Hill Revisited*, Bowden remains best known for photographs of sensual female nudes in landscape settings.

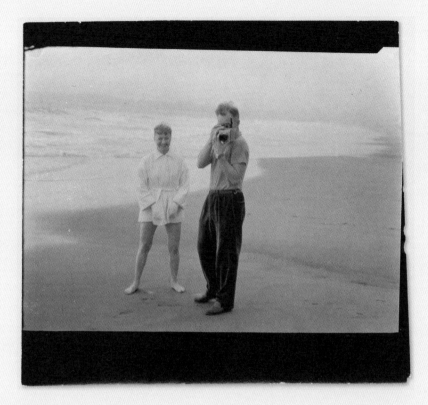

— AUG. 1953 —

**Harry Bowden on Stinson Beach, California, with his wife, Lois,
taking a photo with a camera he made**

Harry Bowden Papers, 1922 – 72

Snapshots are often made on impulse by an alert person who is quick to react to an unforgettable event. An image may be as interesting for the scene as for the subject, even if the subject is a well-known artist, such as painter, printmaker, and photographer Ben Shahn (1898–1969). This snapshot of Shahn looking at postcards in a display case of an Italian museum allows us to share the experience of an artist contemplating art. The view of Shahn, taken from behind, is a picture not of him but of what he sees. The slice of sleeve at the edge of the casually composed snapshot suggests that Shahn is not alone; for a moment, we are there, too, perhaps considering the nature of looking itself.

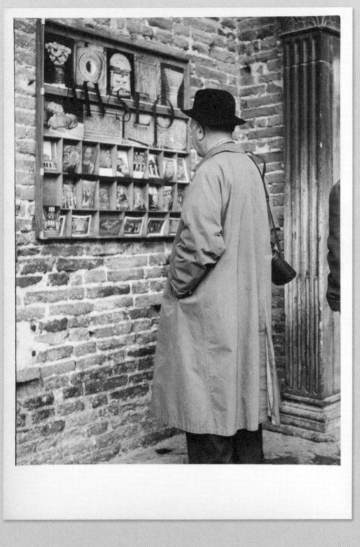

— 1956 —

Ben Shahn looking at postcards in a museum in Italy

BEN SHAHN PAPERS, 1879–1990

More than any of the young painters who followed in the footsteps of the mid-twentieth-century New York abstract expressionists, Fairfield Porter (1907–75) stood apart for his quiet, even dreamlike landscapes and portraits. Many of the portraits were of friends and family. The landscapes were often backyard gardens or vacation spots well known to the Porter family and friends. This snapshot of summer relaxation could almost be one of his paintings. Taken at Great Spruce Head Island, Maine, a summer place his family had owned since the early twentieth century, the image shows Porter ready to swim or just drying off, standing with his dog Bruno.

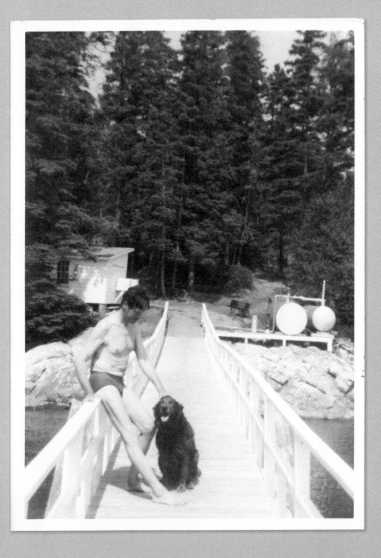

FAMILY
&
FRIENDS

A few publicity snapshots of three famous French artist brothers was what Walt Kuhn was after when he wrote in December 1912 to his friend Walter Pach, who was in Europe lining up artists for the Armory Show, scheduled to open in New York City early the next year. "A snapshot of the Duchamp-Villon brothers in their garden...will help me get a special article on them," declared Kuhn. In January Pach arranged for the brothers to be photographed outside the adjoining studios of Jacques Villon (1875–1963) and Raymond Duchamp-Villon (1876–1918) in Puteaux, a Paris suburb adjacent to Neuilly-sur-Seine. Younger brother Marcel Duchamp (1887–1968) took the train from Paris with Pach—the two would ultimately become close friends—and joined them. Following the February 18 opening of the exhibition, an article on all three brothers appeared in the April 6, 1913, issue of the *New York Sun*. It was good publicity for the traveling exhibition, but none of the exhibition's organizers, not even Kuhn or Pach, anticipated the enormous succès de scandale created by Duchamp's painting *Nude Descending a Staircase (No. 2)*, which marked a decisive turning point in the development of American art.

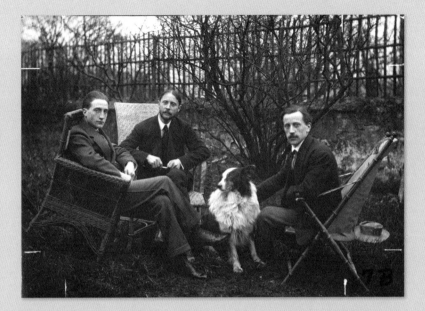

— 1913 —

**Marcel Duchamp, Jacques Villon, and Raymond Duchamp-Villon with dog Pipe
in the garden of Villon's studio, Puteaux, France**

WALT KUHN, KUHN FAMILY PAPERS AND ARMORY SHOW RECORDS, 1859–1978

Dorothy Dehner (1901–94) and David Smith (1906–65) met in 1926, shortly after each arrived in New York City (Smith from Washington, D.C., and Dehner from California) to live their lives as serious artists. Both attended the Art Students League of New York, the most prestigious school of art in the city. They married in 1928. Though they later divorced, Dehner happily recalled those first days together in an oral-history interview with the Archives of American Art at the end of her life: "He was terribly interested and very vital, and I remember, as a reaction from his spats-and-derby kind of dressing, he would go home and get into a pair of old slacks and some things he called romeos—they were great, flapping bedroom slippers with rubber sides, you know. And he would wear those to the [Art Students] League, and this made him distinctive. . . . He was terribly cute and very, very tall and skinny and quite a personality in the group there."

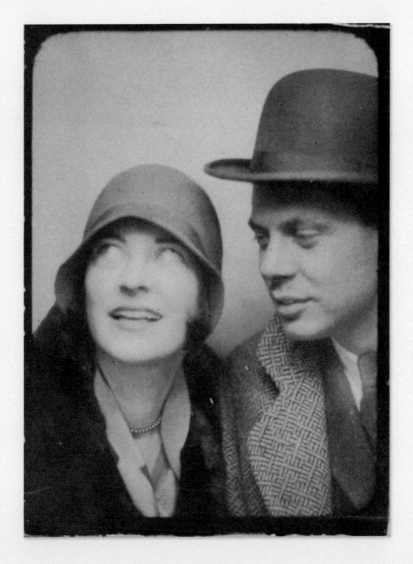

William Glackens (1870–1938) was a painter and illustrator in Philadelphia and New York City, focusing on scenes of city life and street crowds. In 1908 he participated in the groundbreaking exhibition of the group of American artists known as The Eight at the Macbeth Gallery in New York City. His son, writer Ira Dimock Glackens (1907–90), was born in New York City and raised in his father's world of artist friends and colleagues. He published two books about his father: *William Glackens and the Ashcan Group: The Emergence of Realism in American Art* (1957) and *William Glackens and the Eight: The Artists Who Freed American Art* (1984).

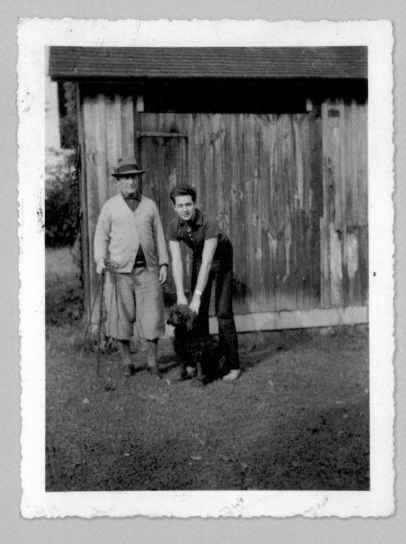

— 1937 —

**William Glackens with his son, Ira,
and their poodle in Stratford, Connecticut**

IRA AND WILLIAM GLACKENS PAPERS, CA. 1900–89

93

When American art collector Chester Dale (1883–1962) visited artists Diego Rivera (1886–1957) and Frida Kahlo (1907–54) in Mexico sometime in the early 1940s, the two had just recently remarried and moved back into the Blue House, Frida's family home in Coyoacán, a borough of Mexico City. Their marriages, both first and second, were passionate but difficult, and each carried on numerous extramarital affairs. By 1940 Rivera was an international celebrity in the art world, known for his monumental murals painted in Mexico and the United States. Kahlo was on the verge of great success and acclaim despite having suffered lifelong health problems and enduring numerous back surgeries and recoveries. Her bedroom became her studio, and her bed became the place from which she held court with lovers, husbands, and, on this day, an art collector eager to meet the (at least temporarily) happy couple. In 1945 Rivera completed a portrait of Dale, now in the collection of the National Gallery of Art in Washington, D.C.

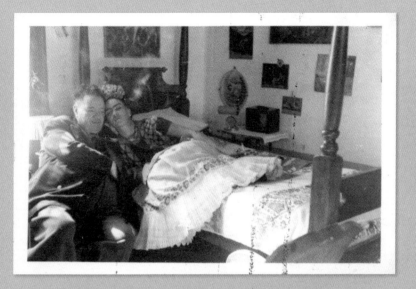

Diego Rivera and Frida Kahlo, Coyoacán, Mexico

Photograph by Chester Dale
Chester Dale Papers, 1897 – 1971

How this snapshot of Pablo Picasso (1881–1973) and his daughter Maya (b. 1935) came to rest among the papers of American abstract expressionist William Baziotes (1912–63) is—like the undocumented journeys of many snapshots—a bit of a mystery. Likely made in Paris, where Picasso remained during World War II, the image captures one of the best-known artists in the world standing as a proud papa with the nine-year-old Maya, the only child of his relationship with his mistress Marie-Thérèse Walter. Likely the photo first belonged to Samuel M. Kootz, who in 1946 organized a show of Picasso's works at his Kootz Gallery in New York City. In the years following, Kootz and his wife, Jane, became quite close with Picasso, as Kootz did with some of the younger artists he represented, including Baziotes.

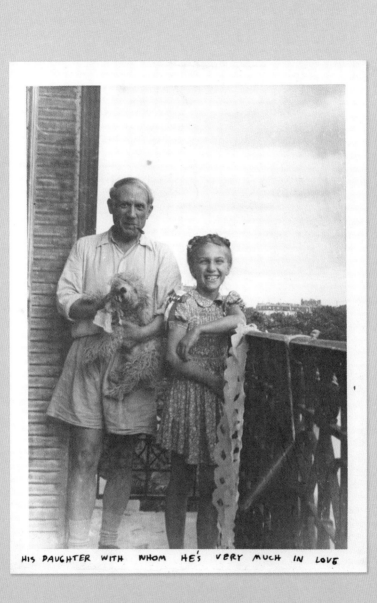

HIS DAUGHTER WITH WHOM HE'S VERY MUCH IN LOVE

— CA. 1944 —

Pablo Picasso and his daughter Maya

WILLIAM AND ETHEL BAZIOTES PAPERS, 1916–92

Marcel Breuer (1902–81) designed and built the house in this snapshot in collaboration with his mentor Walter Gropius (1883–1969) in the late 1930s. Gropius had recently accepted an appointment as chairman of Harvard University's Graduate School of Design, and Breuer had followed to become a member of the Harvard faculty. With the mock seriousness that snapshots can display, the individuals—perhaps the homeowners themselves?—are arranged as modernist actors in an architectonic tableau. Their forms interrupt and possibly comment on the rectilinear rigor of the Bauhaus vocabulary developed by Gropius, Breuer, and their fellow modernists. If form follows function, then the function of these three carefully positioned figures is to remind us that space is made to be inhabited.

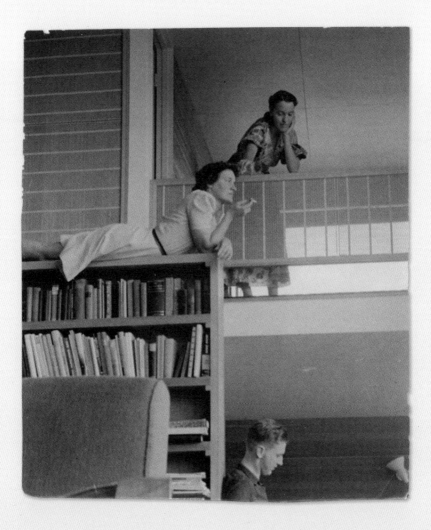

— 1940 —

Breuer House, Lincoln, Massachusetts

Marcel Breuer Papers, 1920 – 86

The scene is familiar. The party's over; it's late, but it's still too early to go home. Gathered at what looks like an all-night cafe is an intriguing assemblage of modernists who seem to have enjoyed a festive, if tiring, evening together. Joining architect Marcel Breuer (fourth from right) is painter Mercedes Matter (1913–2001; far left), an original member of the American Abstract Artists organization, and the German architect Konrad Wachsmann (1901–80; third from left). Wachsmann immigrated to the United States in 1941 and collaborated with Walter Gropius on the Packaged House system, a kit that, the architects boasted, could be assembled in nine hours. On the far right, artist Alexander Calder expresses an irreverent comment on the night.

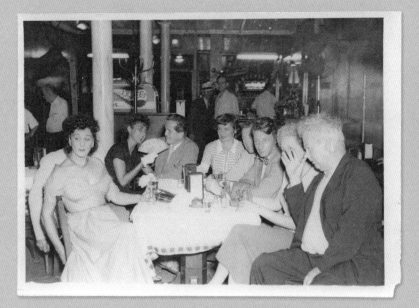

**Marcel Breuer, Mercedes Matter, Konrad Wachsmann,
Alexander Calder, and others**

MARCEL BREUER PAPERS, 1920–86

This lively cafe gathering boasts at least three famous mid-twentieth-century modern architects: Walter Gropius (second from left), Marcel Breuer (right foreground), and Le Corbusier (1887–1965; background, right, with head turned away). Because the back of the snapshot is stamped "UNESCO," the gathering may have been connected to a Paris meeting of the United Nations agency. Le Corbusier had participated in the architectural development of the United Nations headquarters in New York City, which was then under construction. Former Bauhaus director Gropius, however, was excluded from the design team, along with Ludwig Mies van der Rohe, because of his German origin; perhaps this gathering was meant to patch over that slight. Tellingly for the period, in this illustrious gathering of architects only one woman appears—at the front of the photo, obscured in a cloud of smoke.

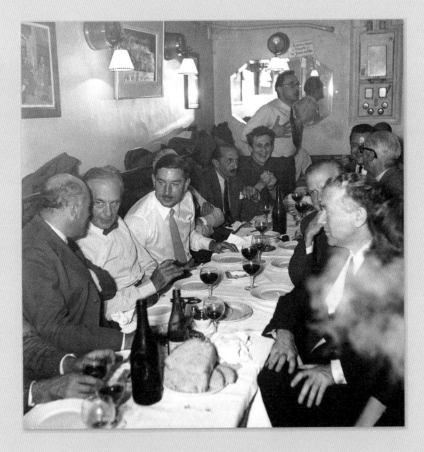

Architects in a Parisian cafe

MARCEL BREUER PAPERS, 1920–86

Philip Pearlstein (b. 1924) was, like his friend Andy Warhol (1928–87), born in Pittsburgh, Pennsylvania. Both graduated from the Carnegie Institute of Technology. Though Pearlstein was older, having returned to school after a stint in the Army during World War II, the two were good friends and shared classes. Along with another student, Dorothy Cantor (b. 1928; later became Pearlstein's wife), they rented a studio in a barn in the summer of 1947. Immediately after graduation the three moved to Manhattan, following in the footsteps of another Carnegie classmate, George Klauber, who had made connections with commercial illustration companies. It isn't certain who made these student snapshots, but they are evidence of an often-present camera.

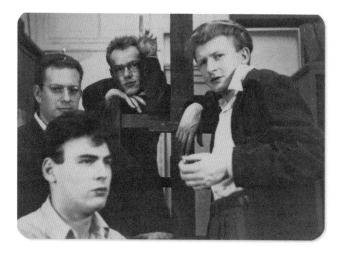

— CA. 1948 – 49 —

Arthur Elias, Philip Pearlstein, Andy Warhol, and Leonard Kessler in a painting studio at the Carnegie Institute of Technology

PHILIP PEARLSTEIN PAPERS, 1949 – 2009

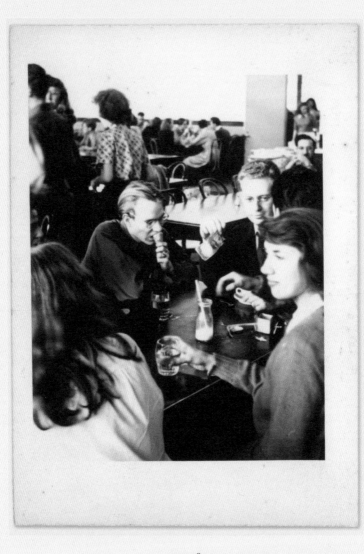

— CA. 1948 —

Andy Warhol on campus at the Carnegie Institute of Technology

PHOTOGRAPH BY PHILIP PEARLSTEIN
PHILIP PEARLSTEIN PAPERS, 1949–2009

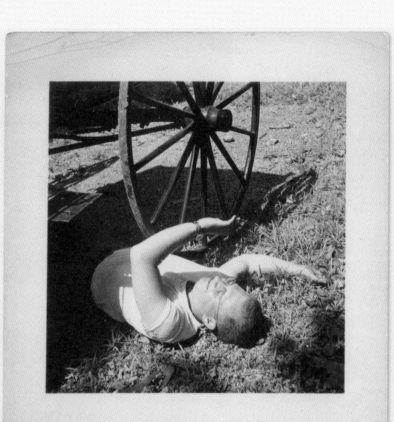

— CA. 1948 —

**A party in a studio of the arts building
at the Carnegie Institute of Technology**

PHILIP PEARLSTEIN PAPERS, 1949–2009

108

Just a few weeks after their graduation from the Carnegie Institute of Technology in June 1949, Philip Pearlstein (who took these snapshots), his soon-to-be wife, Dorothy Cantor, and his young friend Andy Warhol moved to New York City. They rented an sixth-floor walk-up tenement apartment on St. Mark's Place and Avenue A for the summer. Pearlstein's snapshots suggest that an afternoon on the beach at Fire Island must have been a nice way to beat the city heat, though we might question Warhol's beach attire of turtleneck and long pants. Taken before either artist was famous, before pop was hot, Pearlstein's snapshots evoke a time of youthful fun and friendship in a world of artistic potential.

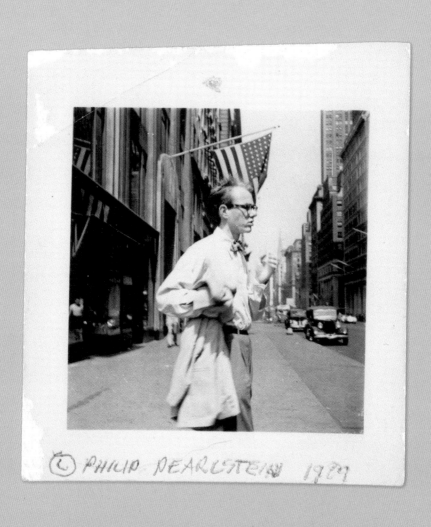

PHILIP PEARLSTEIN 1949

— CA. 1949 —

Andy Warhol in New York City

PHOTOGRAPH BY PHILIP PEARLSTEIN
PHILIP PEARLSTEIN PAPERS, 1949–2009

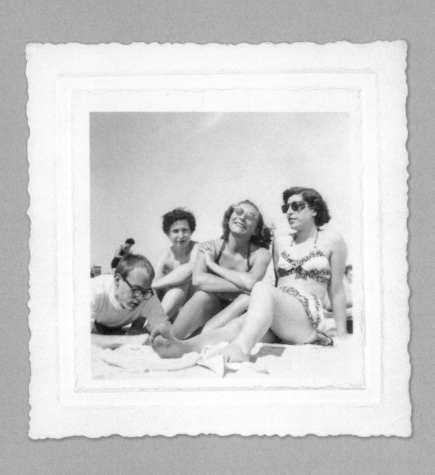

— CA. 1949 —

**Andy Warhol, Dorothy Cantor, Corinne Kessler, and Leah Cantor
on Fire Island Beach, New York**

PHOTOGRAPH BY PHILIP PEARLSTEIN
PHILIP PEARLSTEIN PAPERS, 1949–2009

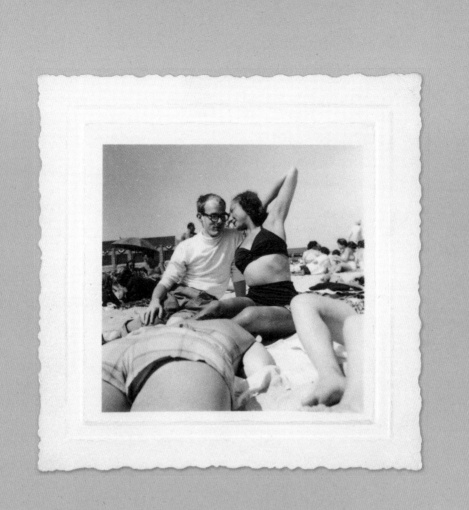

Andy Warhol and Corinne Kessler on Fire Island Beach, New York

Corinne Kessler (b. 1924 and known as Corky) was the sister of Andy Warhol's Carnegie classmate Leonard Kessler (b. 1921). She was a modern dancer and a close friend of Warhol.
PHOTOGRAPH BY PHILIP PEARLSTEIN
PHILIP PEARLSTEIN PAPERS, 1949 – 2009

Though these pictures feature the casual style and off-centered framing shared by many everyday snapshots, the subjects of these photographs are anything but everyday sorts of people. Aline Bernstein Saarinen (1914–72) was one of the nation's best-known critics of art and architecture when in 1954 she married her second husband, the noted Finnish-born architect Eero Saarinen (1910–61). They met when she traveled to Detroit to research a story about the new and acclaimed General Motors Technical Center and to interview the young man who was its architect. For the two, it was love at first sight. Though their time together was short (he died of a brain tumor seven years after they wed), they enjoyed a celebrated life, seemingly encapsulated by these snapshots of a sunny day of boating.

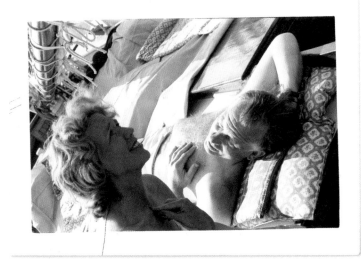

— CA. 1955 —

Aline and Eero Saarinen

ALINE AND EERO SAARINEN PAPERS, 1906 – 77

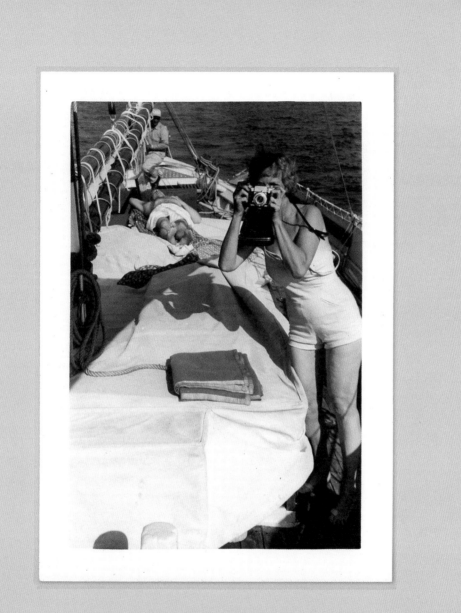

The Little Paris Group was a Washington, D.C., organization of African American women—mostly teachers and government workers—who met regularly to exchange ideas and practice their art. The best-known members of the group, Loïs Mailou Jones (1905–98) and Alma Thomas (1891–1978), enjoyed long and successful careers as both teachers and artists. This image, perhaps taken after one of their regular sketching sessions, is stamped on the reverse "Kay-Dee Photo." Possibly it was an outtake from a more formal group portrait session. Among those pictured are Barbara Buckner, Céline Tabary, Delilah Pierce, Elizabeth Williamson, Bruce Brown, Barbara Linger, Frank West, Don Roberts, Richard Dempsey, Russell Nesbit (model), Loïs Mailou Jones, Alma Thomas, and Desdemona Wade.

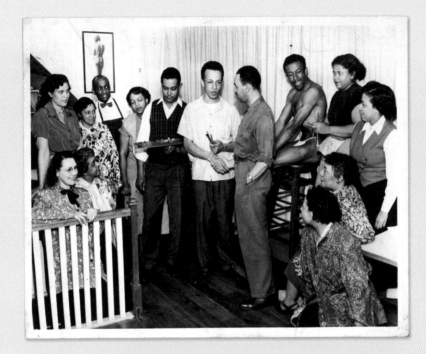

— 1958 —

Little Paris Group in Loïs Mailou Jones's studio in Washington, D.C.

Photograph by Kay-Dee Photo
Alma Thomas Papers, 1894 – 2000

Gertrude Abercrombie (1909–77) was known in Chicago, where she spent most of her life, as "queen of the bohemian artists." A painter and illustrator who crafted a style out of both European surrealism and native realism, her work was inspired by Chicago jazz. Abercrombie was also a gifted improvisational pianist. She and her second husband, music critic Frank Sandiford, held Saturday-night parties and Sunday-afternoon jam sessions at their home with musician friends, including Sonny Rollins, Sarah Vaughan, and Charlie Parker. Dizzy Gillespie (1917–93), shown celebrating his birthday, performed at Abercrombie and Sandiford's wedding.

A note on the back of this snapshot indicates that it was made by art critic and Warhol chronicler David Bourdon (1934–98) on June 5, 1971. Even so, there is no way of knowing what was being celebrated by John, Yoko, and Andy (the posed familiarity of the photo suggests that everyone was on a first-name basis) on that early-summer evening at the Leo Castelli Gallery in New York City. Whatever the occasion, the gallery would have been a likely place for these three art celebrities to meet up. Opened at 4 East Seventy-Seventh Street in 1957, it had by 1971 become the international epicenter for pop, minimalist, and conceptual art. Yoko Ono (b. 1933) was a well-known member of the avant-garde, most notably for being a member of the Dada-inspired Fluxus group. Warhol was already a member of the Castelli stable. And John Lennon (1940–80), besides being a Beatle, could claim art-world connections as Ono's husband. Perhaps the photo marks the trio's first visit to Castelli's recently opened outpost in Manhattan's downtown SoHo district. The snapshot itself suggests something of a performance. Is this a demonstration of pop music embracing pop art?

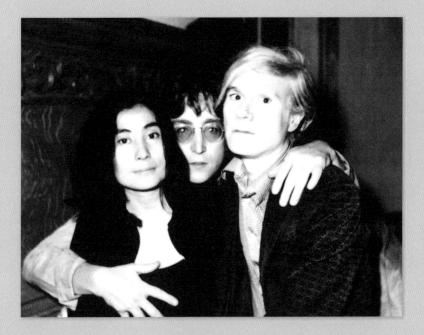

THIS IS ME!

While it may not be a snapshot in the strictest sense, this image of Alexander Calder pretending to wrangle a herd of bulls on a Paris rooftop embraces the informal charm of the best snapshots. Calder lived in Paris between 1926 and 1933. During these years the young American created one of the most beloved works of modern art, a miniature circus that includes more than seventy small acrobats, tightrope walkers, and performing animals. Calder made each character by hand and designed many of the figures to move and interact with one another, sometimes staging performances for friends and family. Like his circus menagerie, these bulls were made to move; each appears to be equipped with a small wheel, all the better to evade the lasso of the artist.

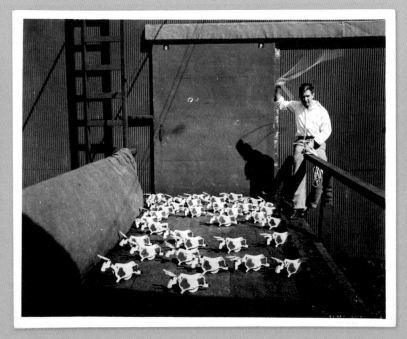

Alexander Calder wrangling toy bulls

PHOTOGRAPH BY LYMAN STUDIO
ALEXANDER CALDER PAPERS, 1926–67

Today photobooths have almost disappeared in deference to digital selfies, but in the early decades of the twentieth century, photobooths could be found almost anywhere and were enjoyed by almost everyone. In train stations, subways, and department-store lobbies from New York to Chicago to Los Angeles, people waiting for trains or looking for a break from their everyday chores loved entering these magical spaces and pulling the curtain. Alone making faces or sharing looks or kisses with friends, the experience was for many both special and intimate. The small strip of images that result from the personal photo session seem almost like a bonus by the end of the intimate process.

In 1934 a special kind of photobooth appeared. Rather than producing strips of images, the Photomatic produced single images with a metal frame; each even came with a built-in stand for display. Like the inexpensive tintype images of an earlier photographic era, these portraits were made for exchange among friends, a form of personal communication and appreciation.

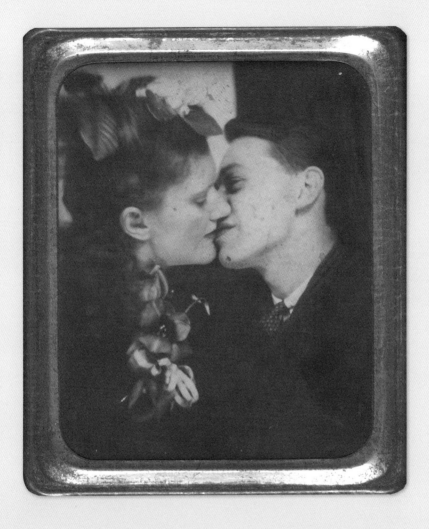

— CA. 1945 —

Gertrude Abercrombie kissing an unidentified individual

GERTRUDE ABERCROMBIE PAPERS, 1880–1986

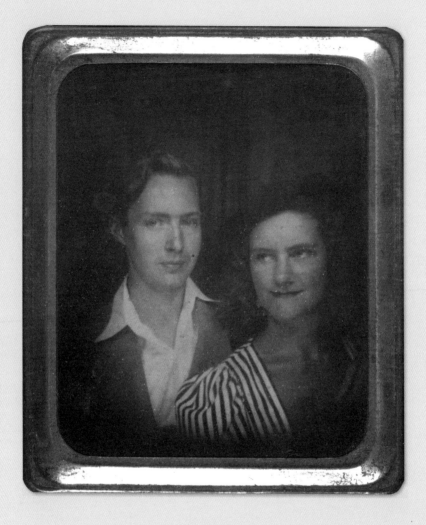

— CA. 1945 —

Gertrude Abercrombie and unidentified individual

GERTRUDE ABERCROMBIE PAPERS, 1880 – 1986

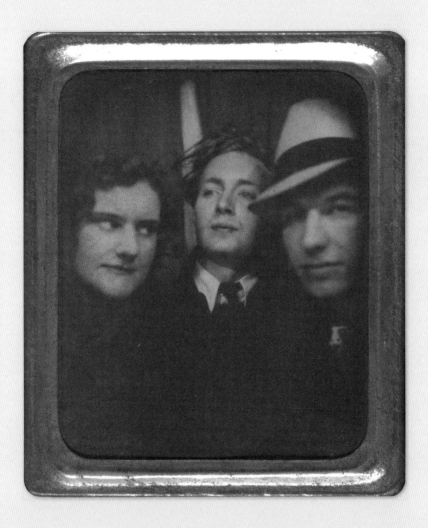

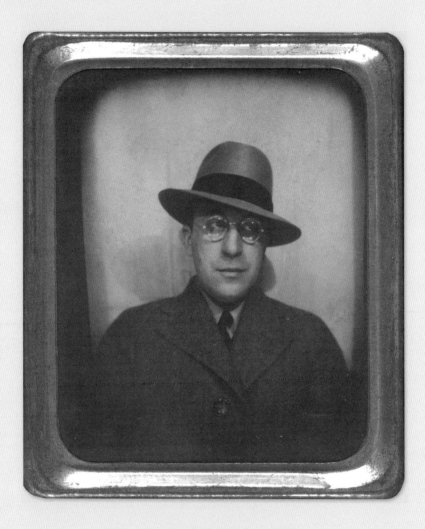

— CA. 1945 —

Samuel H. Woolf

Gertrude Abercrombie Papers, 1880 – 1986

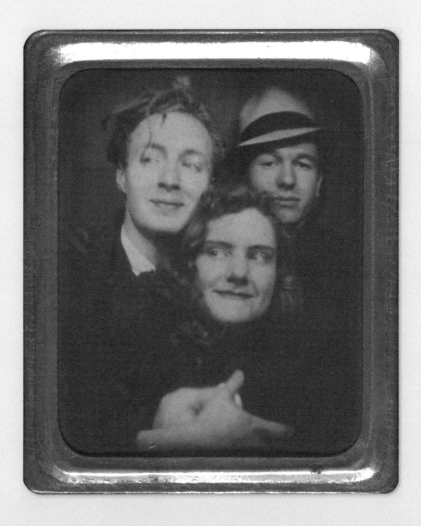

Katharine Kuh (1904–94) and Ansel Adams (1902–84) met shortly after she opened her gallery in 1935—the first devoted to avant-garde art in Chicago. It was also the first Chicago gallery to show photography as art, including an exhibition of work by the young Adams. During the 1930s Adams made several trips from his home in San Francisco to New York, probably stopping over in Chicago. It is only speculation, but perhaps on his way to or from his 1936 solo exhibition at Alfred Stieglitz's gallery An American Place, Adams and Kuh took a moment in Union Station to say hello or good-bye and to make a record of their friendship.

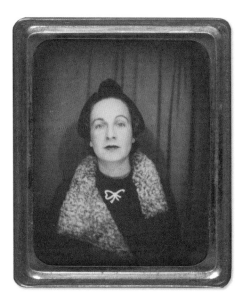

— 1936 —

Katharine Kuh

Katharine Kuh Papers, 1875–1994

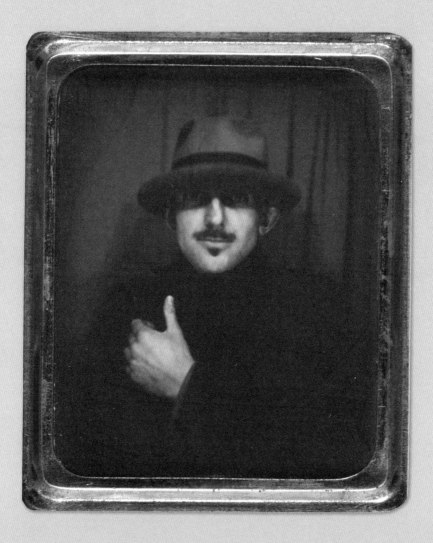

Why we keep some snapshots and lose others—and how the ones we keep merge into the accumulation of the papers of our lives—is often a mystery, even to ourselves. Sometimes a photograph is of someone we wish to remember or simply of someone we have been amazed to know. Sometimes a photograph is just so curious—such as this one of John Dos Passos (1896–1970) walking a dog—that we keep it for amusement alone. Painter Abraham Rattner, from whose papers this snapshot comes, and Dos Passos, one of the major novelists of the post–World War I Lost Generation, knew each other briefly in Paris during the 1930s. Rattner, himself a member of both the American and European avant-gardes, illustrated an article for Dos Passos in *Verve* magazine in 1931, just as the author's major work, *U.S.A.* (a trilogy portraying America as two nations, one rich and privileged and one poor and powerless), was being published.

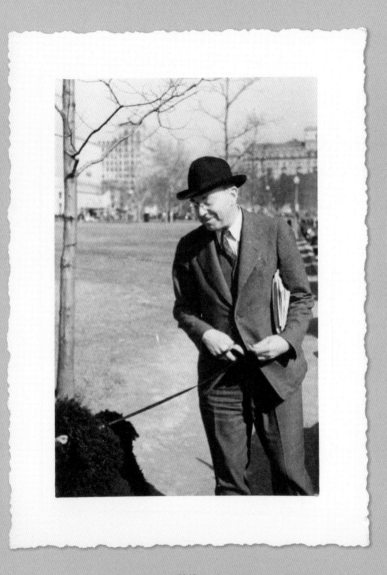

— 1940 —

John Dos Passos walking a dog in New York City

Abraham Rattner and Esther Gentle Papers, 1891–1986

Many snapshots are spontaneous performances of character. Southern California–based artist Helen Lundeberg (1908–99), in partnership with her husband, the artist and teacher Lorser Feitelson (1898–1978), is best known for founding in 1934 the movement they termed "subjective classicism," later referred to by art historians as "post-surrealism." Unlike European surrealists, who were concerned with analyzing their dreams, Lundeberg wanted to make art that revealed meaning, psychological or otherwise, through careful design. Even this snapshot (captured on a day's outing in the countryside east of Los Angeles) suggests a deeper motive as the leaf and the shadow it casts represent a moment when body and mind were psychologically bridged.

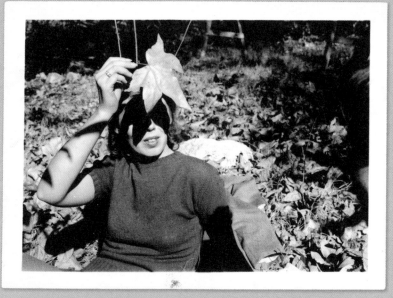

By the end his life, American painter, sculptor, printmaker, photographer, and performance artist Robert Rauschenberg (1925–2008) had become one of the most celebrated artists of the twentieth century. Throughout his career he experimented with new materials and styles to challenge traditional art-making methods. It is tempting to read both pride and brashness in this backroom snapshot, likely taken during preparations for Rauschenberg's first solo exhibition at the Leo Castelli Gallery, then on East Seventy-Seventh Street in New York City. The artist stands in front of one of the earliest and most ambitious of what he termed his "combine paintings." Measuring more than nine feet wide, it combines oil paint, color reproductions, fabric, wood, and metal. Departing from his usual practice of leaving his work untitled, Rauschenberg gave this big, new painting a name: *Charlene* (1954).

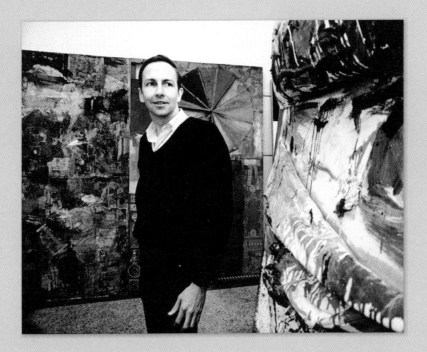

Ellen Hulda Johnson (1910–82) was one of those rare combinations of dedicated scholar and popular professor. It was well known at Oberlin College, in Ohio, where Hulda taught for nearly thirty years, that if you wanted a seat in one of her lectures on the history of art, you had better show up early. She was a scholar of modern masters such as Cézanne and Picasso, but her most significant cultural contribution was her support of post-1945 American artists. Throughout the 1960s and 1970s she curated exhibitions and wrote many articles that helped to establish the careers of young artists involved in the pop art movement. Perhaps she brought a camera on her studio visits with artists such as Jasper Johns (b. 1930) as a form of biographical note taking for her contemporary art history, perhaps as a form of personal remembrance, or perhaps to document the nature of artistic temperament for her eager students.

It is hard to believe that this brooding artist is Jim Dine (b. 1935), one of the most witty and imaginative members of the pop art generation. Along with artists Claes Oldenburg, Red Grooms, and others, Dine staged many of the first performances known as Happenings. His paintings from that period, which included tools and pieces of clothing collaged onto the canvas, were an equally irreverent break with tradition. At the time that art historian and early pop art supporter Ellen Hulda Johnson took this snapshot, Dine was fast becoming a recognized artist. He would soon have solo shows at the prestigious Sidney Janis Gallery in New York City.

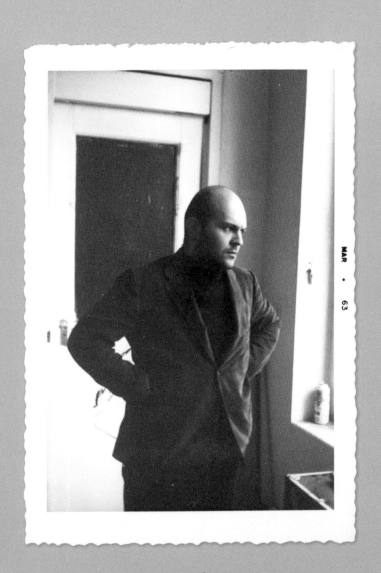

MAR · 63

— MAR. 1963 —

Jim Dine in his New York studio

PHOTOGRAPH BY ELLEN HULDA JOHNSON
ELLEN HULDA JOHNSON PAPERS, 1939–80

143

Painter Kenneth Noland (1924–2010) is shown inspecting one of his paintings in his studio in Shaftsbury, Vermont. Noland, who pioneered the use of shaped canvases, was one of the best-known American color-field painters. The 1960s were productive years for him: not only was he a featured artist in the American pavilion at the Venice Biennale in 1964, but he was also included in the exhibition *Post-Painterly Abstraction*, curated by Clement Greenberg in the same year, which traveled the country and helped to establish color-field painting as an important new movement in contemporary art. The decade also marked the beginning of his long association with the photographer of this studio snapshot, art dealer André Emmerich (1924–2007), whose important New York City gallery mounted almost annual exhibitions of Noland's work.

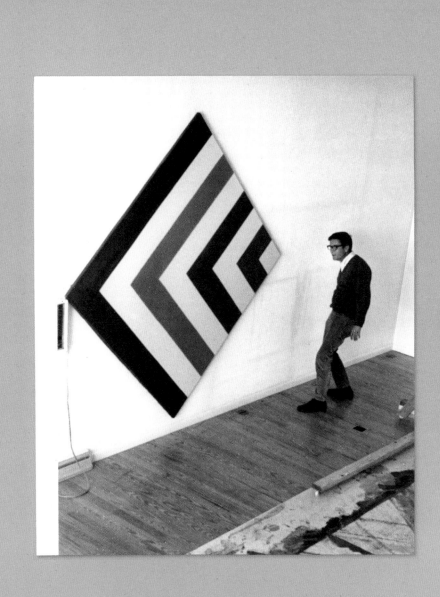

— 1965 —

Kenneth Noland in his studio in Shaftsbury, Vermont

Photograph by André Emmerich
André Emmerich Gallery Records and André Emmerich Papers, 1929–2008

145

For much of the second half of the twentieth century, André Emmerich presided over one of the world's most influential art galleries. Born in Europe and educated in America, he initially thought he would be a writer. Instead, with sophisticated aplomb he became a gallery owner whose exhibitions were lauded in newspapers as much for the clean, white space of the gallery as for the art. A strong advocate of abstract sculpture, he moved his New York gallery twice to accommodate larger work, such as these pieces by Anthony Caro. This snapshot was taken on a visit to Caro's backyard studio in Milan, Italy.

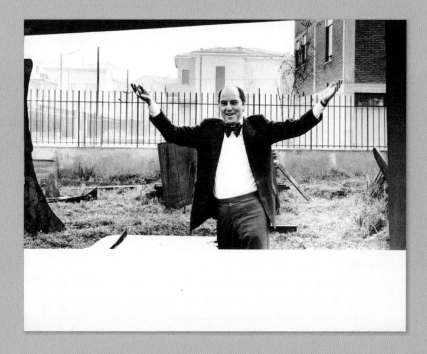

In the spring and summer of 1982, David Hockney (b.1937), an English painter who was well known on both sides of the Atlantic and both coasts of the United States for his draftsmanship, introduced a radically new body of work. His exhibition *Drawing with a Camera* took place on the West Coast at the L. A. Louver gallery and on the East Coast at the André Emmerich Gallery in New York City. These exhibitions consisted of portraits assembled from sx-70 Polaroid photographs arranged in rectangular grids, each of which showed only a detail of the subject. One of these "camera drawings" is leaning against the wall at the right in this snapshot. While Hockney had used photographs as inspiration for and references in earlier paintings (and would continue to do so), the Polaroid collages mark the artist's growing interest in photographs as works of art in themselves.

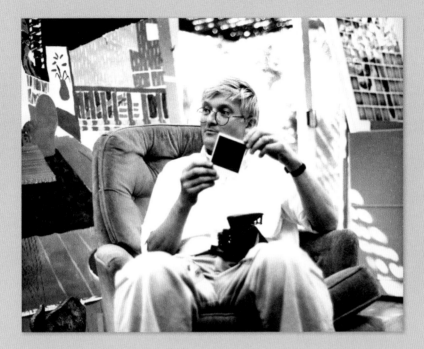

David Hockney at his studio in Los Angeles

PHOTOGRAPH BY ANDRÉ EMMERICH
ANDRÉ EMMERICH GALLERY RECORDS AND ANDRÉ EMMERICH PAPERS, 1929–2008

C olin de Land (1955–2003) and Pat Hearn (1955–2000) met when each opened a gallery in New York City's East Village in the mid-1980s. Hearn's eponymous gallery on Ninth Street and Avenue D showed a wide range of contemporary painting, installation, photography, and video. De Land's first gallery, Vox Populi, was around the corner. They married in 1999. Together they organized the Gramercy International Contemporary Art Fair, held in various cities, which was a precursor of The Armory Show in New York City, now an annual art-world event. Hearn and de Land used photography in their lives away from the galleries for the express purpose of producing personal documents. The enormous volume of images now in the Archives of American Art describes an almost compulsive desire to record as many minutes of life as possible. These include candid snapshots of exhibition openings, art fairs, vacations, social gatherings, and New York City street scenes. Parties at their apartment were noteworthy. Christmas was especially celebrated. Continuous sequences of snapshots combine unrehearsed intimacy with an artfulness learned from the picture world in which they lived. Hearn died of liver cancer in August 2000. De Land died three years later.

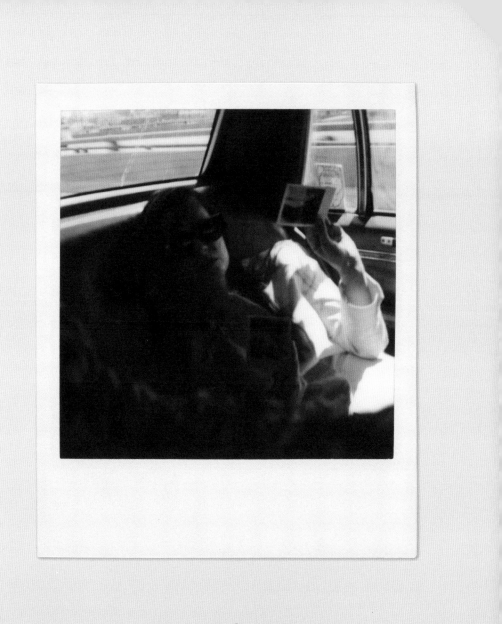

— DEC. 1994 —

**Room at the Chateau Marmont
during the Gramercy International
Contemporary Art Fair in New York City**

*One of the photos propped up on top of the minifridge is a work by
Art Club 2000,* Untitled (Cooper Union, Puzzle Party 1, 1994).
COLIN DE LAND COLLECTION, 1968–2008

— DEC. 28, 1995 —

**Christmas at the home of Pat Hearn
and Colin de Land**

COLIN DE LAND COLLECTION, 1968–2008

— CA. 1988 —

Pat Hearn and her dog Chi-Chi

COLIN DE LAND COLLECTION, 1968–2008

— CA. 2000 —

Interior of a taxicab

COLIN DE LAND COLLECTION, 1968–2008

— OCT. 5, 2000 —

Two unidentified people at a snack bar

COLIN DE LAND COLLECTION, 1968–2008

154

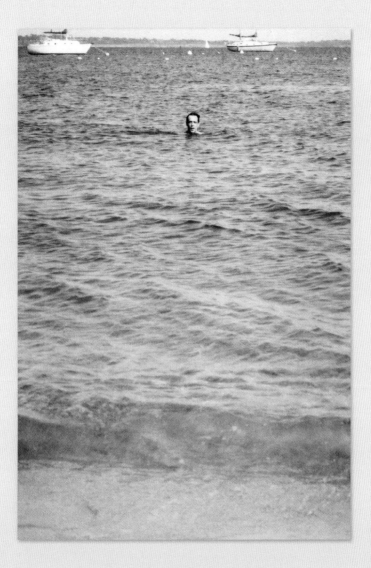

Colin de Land swimming in the ocean

COLIN DE LAND COLLECTION, 1968–2008

Colin de Land's American Fine Arts, Co. on Wooster Street in SoHo, like his earlier gallery, showed a wide range of cutting-edge art, from postmodernist critiques and video installations to new abstract painting. It also served as something of a community center for the late twentieth-century New York avant-garde. Always provocative, de Land functioned as gallery director, party organizer, and art-world entertainer. Cameras loaded with film, including Polaroid instant cameras, were always on hand in the gallery; anyone and everyone were invited to use them. In this way, a seemingly continuous stream of photographs as life was produced. The pictures document in an appropriately nontraditional way the everydayness of de Land's gallery life: installations, the flow of gallerygoers, backroom hanging out, and, above all, the parties.

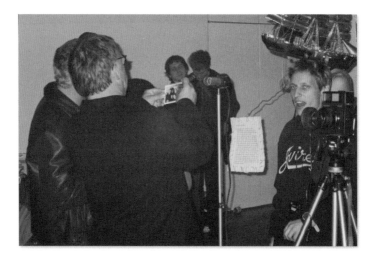

— CA. 2000 —

Patterson Beckwith and others at a party

COLIN DE LAND COLLECTION, 1968 – 2008

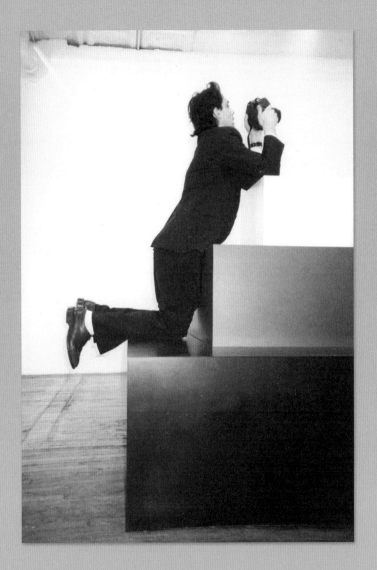

— NOV. 1995 —

Colin de Land taking a photograph

COLIN DE LAND COLLECTION, 1968 – 2008

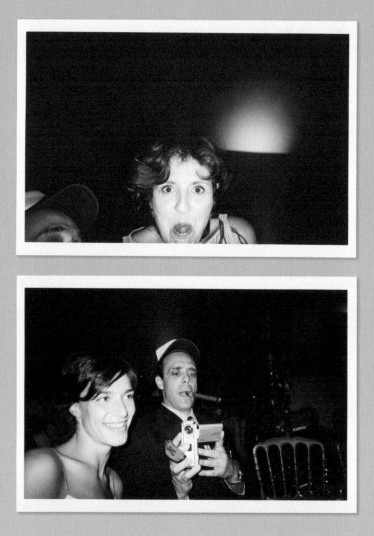

— CA. 2000 —

**Unidentified woman sticking
her tongue out**

Colin de Land Collection, 1968–2008

— 2000 —

**Colin de Land and an unidentified
woman at a party**

Colin de Land Collection, 1968–2008